color
5

DESIGNER'S GUIDE TO
color
5

Ikuyoshi Shibukawa
and Yumi Takahashi

ANGUS
& ROBERTSON

An imprint of HarperCollins*Publishers*

AN ANGUS & ROBERTSON BOOK
An Imprint of HarperCollinsPublishers

First published in the United Kingdom by
Angus & Robertson (UK) in 1992
An Imprint of HarperCollinsPublishers Ltd
First published in Australia by
Collins/Angus & Robertson Australia in 1992
A division of HarperCollinsPublishers
(Australia) Pty Ltd
First published in the USA by Chronicle
Books in 1991

Angus & Robertson (UK)
77-85 Fulham Palace Road, London Wy 8JB
United Kingdom
Collins/Angus & Robertson Publishers Australia
Unit 4, Eden Park, 31 Waterloo Road,
North Ryde, NSW 2113, Australia
William Collins Publishers Ltd
31 View Road, Glenfield, Auckland 10,
New Zealand

Super Colors for Professional Use 2 by
Ikuyoshi Shibukawa and Yumi Takahashi was
first published in Japan by Kawade Shobo
Shinsha Publishers
The authors assert the moral right
to be identified as the authors of this work.

A catalogue record for this book is available
from the British Library

ISBN 0 207 17141 6

Printed in Japan

Preface

- This book, published as the fifth volume in the Designer's Guide series, is a color scheme manual that classifies colors according to "image."
- The color images are broadly divided into two types. One type draws forth such human feelings as happiness and loneliness. The other type is associated with or calls to mind tangible qualities or objects, such as ethnicity or Japanese style.
- Color images differ somewhat depending on each person's individual experiences. The headings in this book can be viewed as fundamental divisions within the classification of such images. When people understand the details of the images that have been organized using those divisions, they can gain experience in responding to the concrete aim of a color scheme and freely manipulate the color scheme. This is a primary requirement for professionals who deal with colors in whatever field they work.
- In those sections where the descriptions of such general tones as "light," "dark," and "subdued," are more easily understood, such headings are provided. Subheadings with a ■ represent related color images. They are not just reworded descriptions. Subheadings with a ☆ represent unique color tones among colors of a similar image. They are specifically singled out as independent subheadings following the main heading.
- Color Combination Techniques (page 110) provides samples and descriptions that introduce the essential techniques for creating types of color schemes, from similar-color color schemes to night color schemes. Night Color Schemes (page 109) might be an unfamiliar expression, but this and the other categories form a framework for creating color schemes, and an understanding of it will greatly increase the capabilities of combining colors based on their associations.
- Y (yellow), M (magenta), C (cyan), and BL (black) in each color scheme are designations of density for printing purposes. Numbers can be used to specify the coloration of the color draft.
- The attached color chart is the manual of individual colors classified by tones. In printing, the paper quality makes a big difference in the printed colors. In order to respond to the requests from professionals who desire more accurate renditions, we especially added high quality paper versions.

CONTENTS

PALE

Similar images

- Transparent
- Faint
- Fleeting

• As lightness values increase, the variations in color hues (yellow, red, blue) become subtle. The impression left by the tone classified as pale is much stronger than the details of the hues. Pale can be called a typical tone color scheme. It is much more beautiful when the tone is as controlled as possible. Because pale is expressed by an overall tone, it is suitable for color schemes having many colors rather than just a few.

• A combination of pale colors makes the area where two colors meet somewhat indistinct. When each needs to be emphasized, colors with contrasting hues should be used. Because this tone is gentle, even contrasting colors are compatible. When a pattern is used against a ground color, it is effective to separate the area into two large zones, such as a warm color group and a cold color group.

• When one unclear color is added to one or more clear colors, the total impression becomes full-bodied, and a somewhat mature atmosphere is thus created, as on page 6. When warm colors or unclear colors become extremely pale, a feeling of transparency is produced, and a sense of coolness is conveyed.

Other references:
• Tranquil (p. 18) • Spring (p. 96)

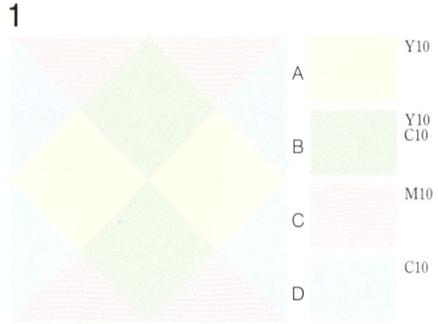

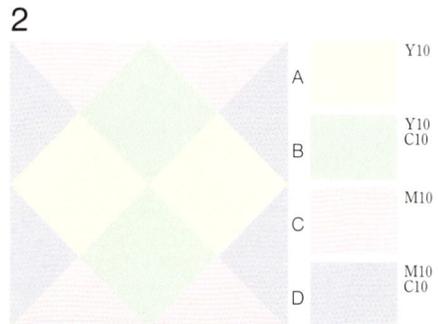

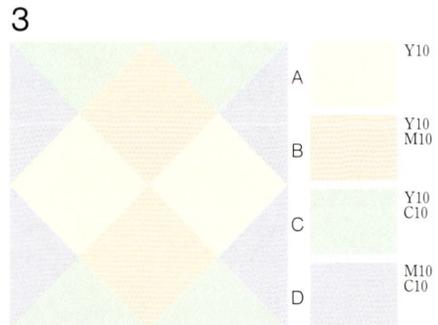

1

A Y10

B Y10 C10

C M10

D C10

2

A Y10

B Y10 C10

C M10

D M10 C10

3

A Y10

B Y10 M10

C Y10 C10

D M10 C10

4

A Y10

B Y10 M10

C M10 C10

D M10

5

A — Y20
B — C20
C — M20
D — M20 C20

9

A — Y20 M10
B — M10 C20
C — M20
D — Y20 C10

6

A — Y20
B — Y20 C20
C — M20 C20
D — C10

10

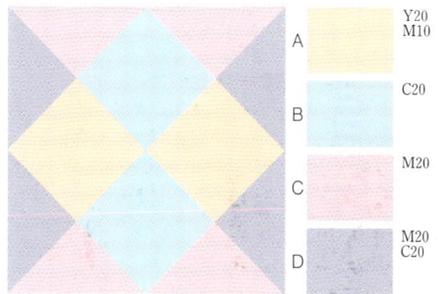

A — Y20 M10
B — C20
C — M20
D — M20 C20

7

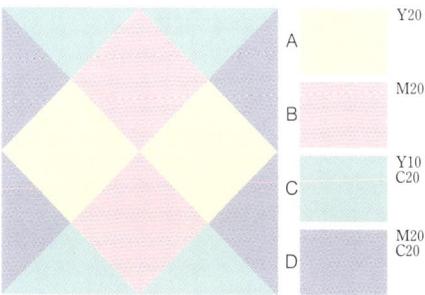

A — Y20
B — M20
C — Y10 C20
D — M20 C20

11

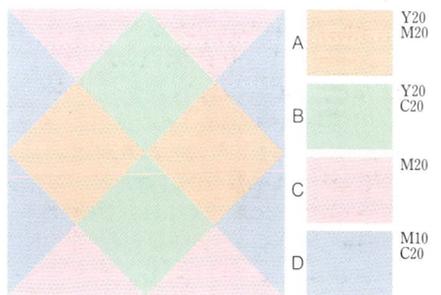

A — Y20 M20
B — Y20 C20
C — M20
D — M10 C20

8

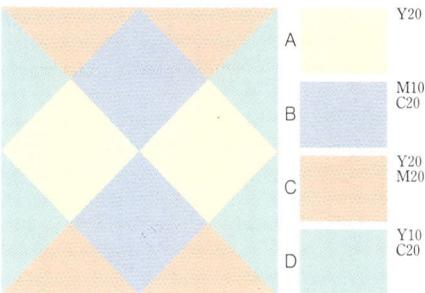

A — Y20
B — M10 C20
C — Y20 M20
D — Y10 C20

12

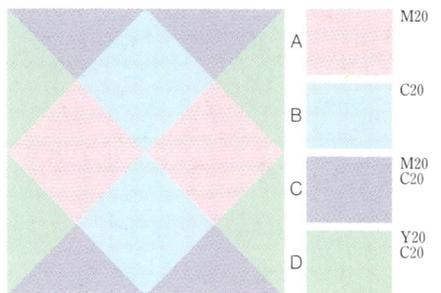

A — M20
B — C20
C — M20 C20
D — Y20 C20

5

13

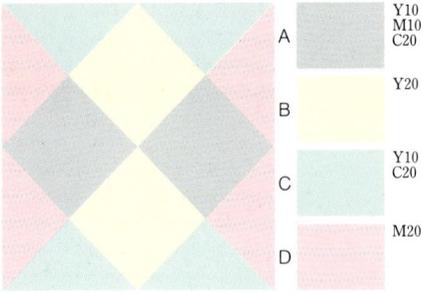

A — Y10 M10 C20
B — Y20
C — Y10 C20
D — M20

17

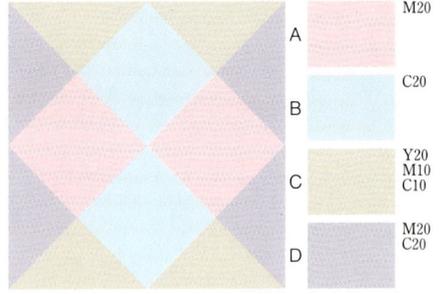

A — M20
B — C20
C — Y20 M10 C10
D — M20 C20

14

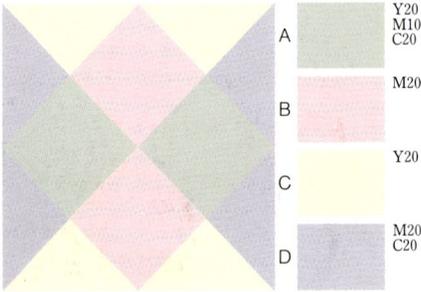

A — Y20 M10 C20
B — M20
C — Y20
D — M20 C20

18

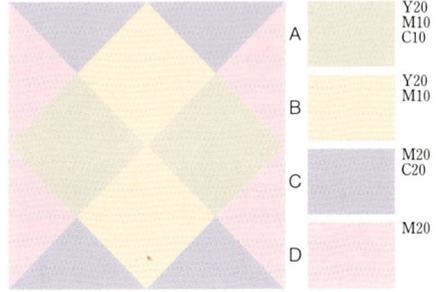

A — Y20 M10 C10
B — Y20 M10
C — M20 C20
D — M20

15

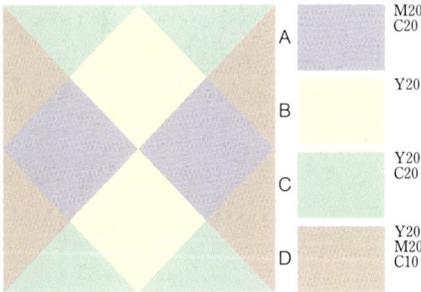

A — M20 C20
B — Y20
C — Y20 C20
D — Y20 M20 C10

19

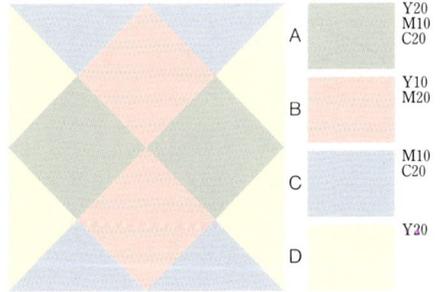

A — Y20 M10 C20
B — Y10 M20
C — M10 C20
D — Y20

16

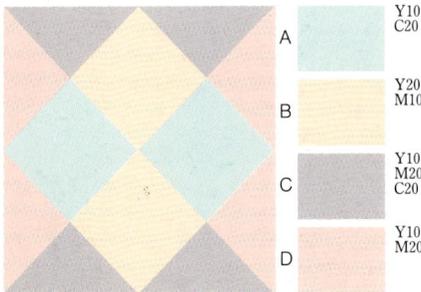

A — Y10 C20
B — Y20 M10
C — Y10 M20 C20
D — Y10 M20

20

A — M20 C20
B — Y10 C20
C — Y10 M10 C20
D — Y20 M20

21

A	Y20
B	Y10 C20
C	Y20 M10 C20
D	Y10 M20 C20

25

A	Y20 M10 C10
B	Y20 M20 C10
C	Y20 M10 C20
D	Y10 M20 C20

22

A	Y20 M20
B	M10 C20
C	Y20 M10 C10
D	Y20 M20 C20

26

A	Y20 M10 C10
B	Y10 M10 C20
C	Y10 M20 C10
D	Y10 M20 C20

23

A	M20
B	M20 C20
C	Y20 M10 C10
D	Y20 M10 C20

27

A	Y20 M10 C10
B	Y20 M10 C20
C	Y20 M20 C10
D	Y10 M10 C20

24

A	M20
B	Y20 C20
C	Y20 M20 C20
D	Y20 M10 C10

28

A	Y20 M20 C10
B	Y10 M10 C20
C	Y10 M20 C10
D	Y10 M20 C20

ROMANTIC
*Fantasia–like

Similar images

- Cute
- Sweet
- Cheerful
- Fairy Tale–like

• In this world of sweet and fanciful colors, the soft tones of the so-called pastels, from light to bright, are key. Color schemes arranged using colors in this tone give an impression of sweetness and cuteness.

• Pink is an especially important color in conveying a romantic image. Making pink the main color in combination with orange and yellow results in strong images of happiness, youthfulness, and innocence. On the other hand, making pink the main color in combination with blue and purple is romantic rather than cute.

• When cold color groupings such as blue (the main color), purple, and green are coordinated, a fantastic and mysterious atmosphere is created, like a fairy world bathed in moonlight (see page 13). Although such colors give off ennui, they are essential in creating an impression of nighttime or of water submersion.

Other references:
• Refreshing (p. 14–15)
• Pleasant (p. 66–67)
• Spring (p. 96–97)

29

A — Y50
B — M50
C — M50 C50
D — M30 C50

30

A — Y50
B — M50 C10
C — Y20 C60
D — Y30 M50

31

A — Y50 M10
B — Y10 C50
C — M30 C50
D — Y10 M50

32

A — Y50 M10
B — M50 C30
C — Y50 C50
D — Y20 M60

33

A	Y50 M30
B	Y50 C10
C	M50 C40
D	M50 C10

37

A	Y30 M50
B	M60 C20
C	Y60 M10
D	M30 C60

34

A	Y50 M30
B	M30 C50
C	M50 C20
D	Y50 C40

38

A	Y30 M50
B	Y20 C50
C	M30 C50
D	M50 C30

35

A	Y50 M50
B	M60 C20
C	M50 C50
D	Y20 C60

39

A	Y10 M50
B	M20 C50
C	Y20 C50
D	Y50 M10

36

A	Y50 M50
B	Y50 C20
C	M60 C30
D	M50 C60

40

A	Y10 M50
B	M60 C50
C	M30 C50
D	Y50 C10

41

A	M50
B	Y50 M30
C	Y20 C50
D	M20 C50

45

A	M50 C30
B	Y20 M50
C	M10 C50
D	Y50 C10

42

A	M50
B	Y30 C50
C	M30 C50
D	Y50

46

A	M50 C30
B	Y10 C50
C	Y50 M10
D	Y10 M50

43

A	M50 C10
B	M30 C50
C	Y20 C50
D	Y50 M30

47

A	M50 C50
B	M50
C	Y20 C50
D	Y50 M10

44

A	M50 C10
B	Y50
C	Y50 C30
D	M20 C50

48

A	M50 C50
B	Y50 M30
C	Y50 C10
D	Y10 M60

49

A	M30 C50
B	Y10 M50
C	Y50 M10
D	Y10 C50

53

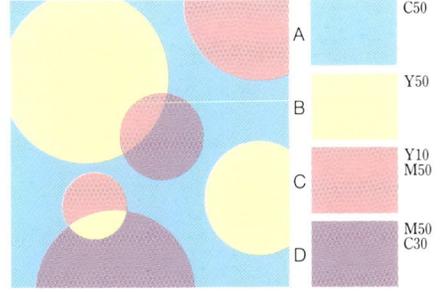

A	C50
B	Y50
C	Y10 M50
D	M50 C30

50

A	M30 C50
B	Y30 C50
C	Y40 M60
D	Y60 M20

54

A	C50
B	Y10 M50
C	M60 C20
D	Y50 M20

51

A	M10 C50
B	M50
C	Y50
D	M60 C20

55

A	Y10 C50
B	M50
C	M40 C50
D	Y50 M30

52

A	M10 C50
B	M60 C10
C	M50 C30
D	Y30 M50

56

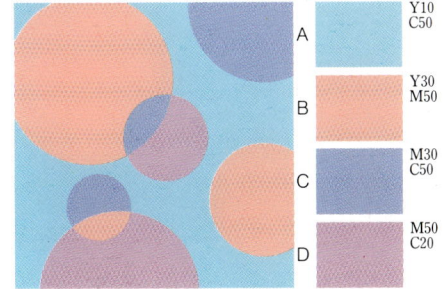

A	Y10 C50
B	Y30 M50
C	M30 C50
D	M50 C20

57

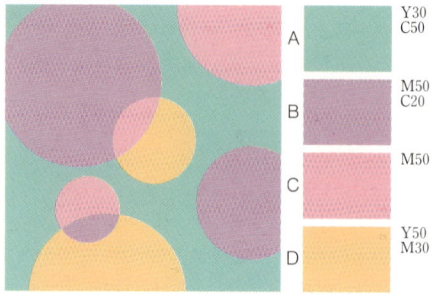

A — Y30 C50
B — M50 C20
C — M50
D — Y50 M30

61

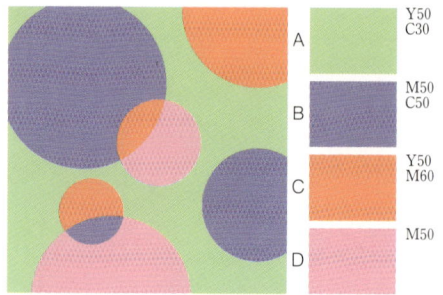

A — Y50 C30
B — M50 C50
C — Y50 M60
D — M50

58

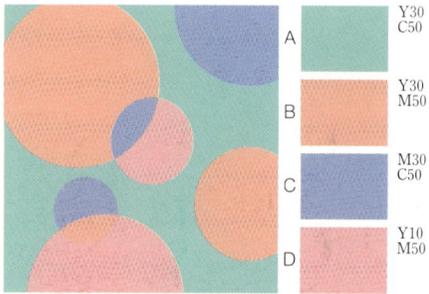

A — Y30 C50
B — Y30 M50
C — M30 C50
D — Y10 M50

62

A — Y50 C30
B — Y10 M50
C — M30 C60
D — M50 C20

59

A — Y50 C50
B — M50
C — M50 C50
D — Y50 M20

63

A — Y50 C10
B — Y50 M30
C — Y50 M60
D — M30 C50

60

A — Y50 C50
B — Y50 M50
C — M60 C20
D — M30 C60

64

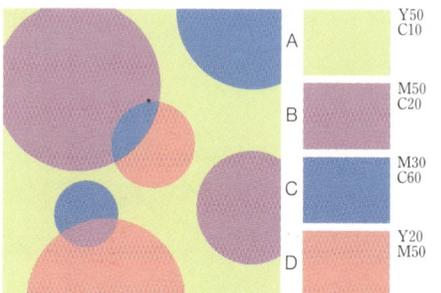

A — Y50 C10
B — M50 C20
C — M30 C60
D — Y20 M50

65

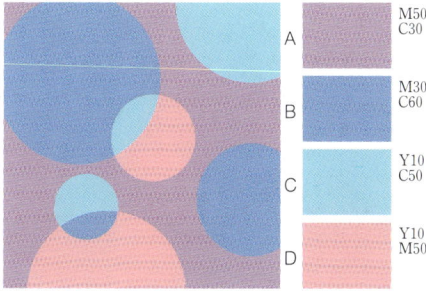

A	M50 C30
B	M30 C60
C	Y10 C50
D	Y10 M50

69

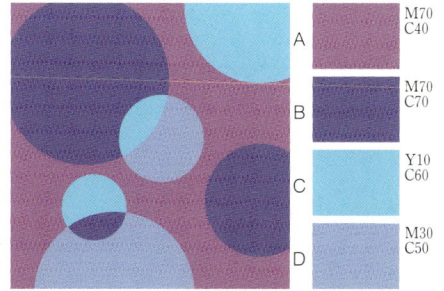

A	M70 C40
B	M70 C70
C	Y10 C60
D	M30 C50

66

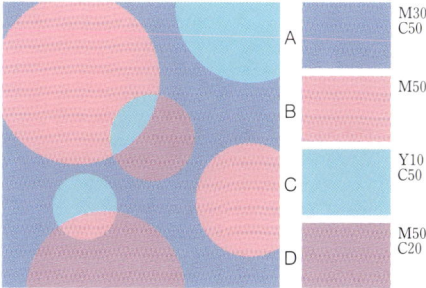

A	M30 C50
B	M50
C	Y10 C50
D	M50 C20

70

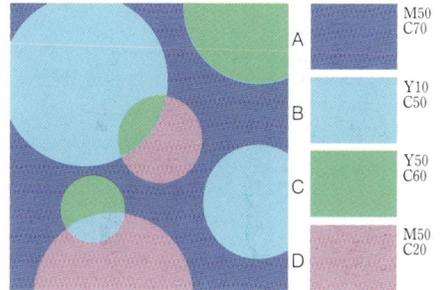

A	M50 C70
B	Y10 C50
C	Y50 C60
D	M50 C20

67

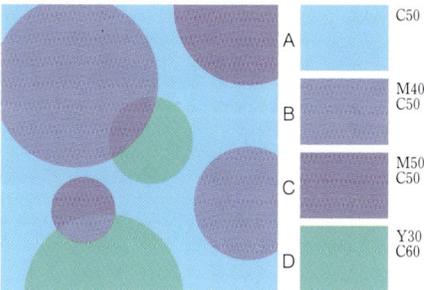

A	C50
B	M40 C50
C	M50 C50
D	Y30 C60

71

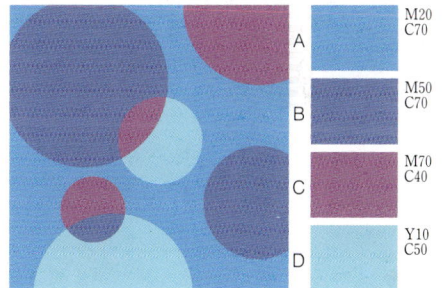

A	M20 C70
B	M50 C70
C	M70 C40
D	Y10 C50

68

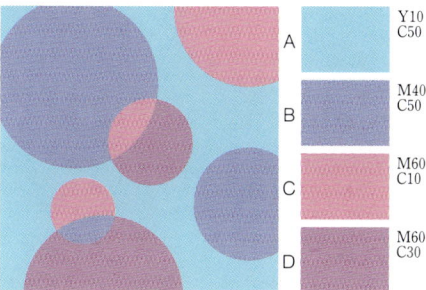

A	Y10 C50
B	M40 C50
C	M60 C10
D	M60 C30

72

A	Y20 C70
B	M50 C10
C	M40 C70
D	M60 C70

13

REFRESHING

Similar images

- Clean
- Fresh-Faced
- Invigorating
- Clear

• This color scheme is like a pleasant breeze blowing through gentle sunshine, making the young leaves quiver. The cleanness of this refreshing feeling is its strong point.

• In order to express such a refreshing quality, the three conditions of brightness, cold colors, and contrast are required. First of all, the entire area uses bright and clear pastel tones ranging from light to bright. The cold color group, with blue as the main color, is used for the hues. White or a cold yellow, such as lemon, is added and provides a contrast in lightness. This is the easiest way to create a refreshing impression.

• The addition of pink and purple create a romantic ambience. Mint and orange offer an impression of pleasantness and robustness. When only blues and greens are combined, a cooler image results. Although the ambience changes somewhat in accordance with the number of colors and the shape allowances, if at least the three above conditions are satisfied, then the color scheme will be successful.

Other references:
• Romantic (p. 8–12) • Lighthearted (p. 16–17)
• Sporty (p. 38–39) • Cool/Cold (p. 64)
• Spring (p. 96–97) • Summer (p. 98)

73

A — Y50
B — M20 C60
C — M50
D — Y10 C50

74

A — M20 C50
B — Y50
C — C50
D — Y30 C50

75

A — M30 C50
B — Y10 C50
C — Y50 M10
D — M50 C50

76

A — Y20 C50
B — Y50
C — Y50 M40
D — M50 C30

77

A — Y10 C70
B — Y70
C — M60
D — M30 C70

81

A — Y70 M10
B — M40 C70
C — C70
D — Y30 C70

78

A — Y30 C70
B — Y70 M10
C — C70
D — M30 C70

82

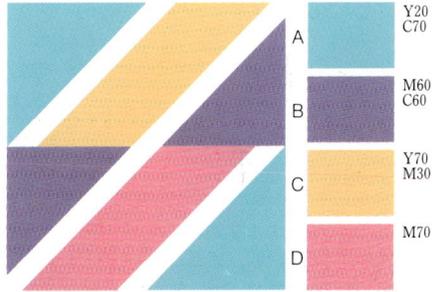

A — Y20 C70
B — M60 C60
C — Y70 M30
D — M70

79

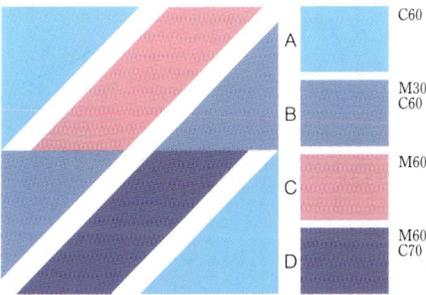

A — C60
B — M30 C60
C — M60
D — M60 C70

83

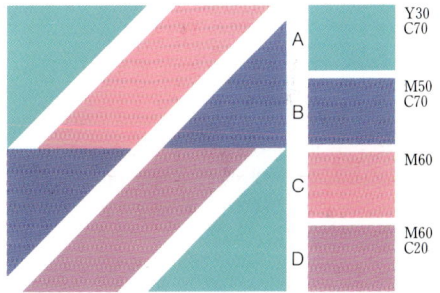

A — Y30 C70
B — M50 C70
C — M60
D — M60 C20

80

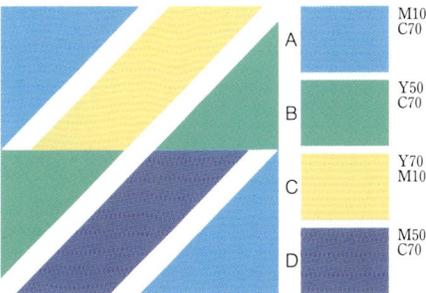

A — M10 C70
B — Y50 C70
C — Y70 M10
D — M50 C70

84

A — M20 C70
B — M50 C70
C — Y10 C70
D — Y50 C70

LIGHTHEARTED

Similar images

- Sporty
- Invigorating
- Distinct

• This lively and clear color scheme conveys the feeling of being out-doors or at a resort during summer. This color category shares qualities with the previously discussed Refreshing scheme.

• In order to convey a feeling of lightheartedness in this color scheme, some lightness contrast is essential.

• With respect to hues, yellow is the first color to become prominent because it is bright, robust, and healthy. Next is blue, which is necessary to make a contrast with yellow. In addition, blue leaves a clean impression. A combination of yellow and blue is therefore the basic color scheme for lighthearted.

• When pleasant colors, such as pink, orange, mint, and so on, are added to the schome, a buoyant and invigorating, even sporty impression is created. Clear colors, which are more transparent and clean-looking than unclear colors, are most suit-able here.

• When a lightness contrast is imparted to these refreshing bright tones, the overall rhythm created produces an active and sporty feeling.

Other reference items:
- Refreshing (p. 14–15)
- Sporty (p. 38–39)
- Summer (p. 98)

85

A	Y60
B	Y10 C70
C	M60
D	M50 C70

86

A	Y60 M10
B	M30 C70
C	Y70 C30
D	M70 C70

87

A	M60
B	Y10 C70
C	Y70 M30
D	M70 C60

88

A	Y10 C50
B	M40 C70
C	Y70 M20
D	M70 C70

89

A	Y70
B	Y30 C80
C	Y70 M50
D	M50 C80

93

A	Y70 M20
B	M30 C80
C	Y80 C70
D	M70 C80

90

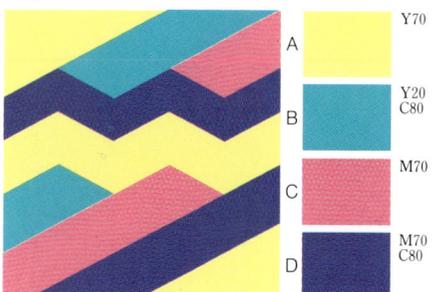

A	Y70
B	Y20 C80
C	M70
D	M70 C80

94

A	Y70 M20
B	M50 C70
C	Y10 C70
D	M70 C80

91

A	Y70
B	M30 C80
C	Y20 C70
D	M70 C70

95

A	M60
B	M40 C70
C	Y20 C60
D	M80 C80

92

A	Y70
B	M30 C80
C	Y70 M60
D	M80 C70

96

A	Y70 C30
B	M50 C70
C	Y30 C70
D	M80 C80

17

TRANQUIL

*Natural

Similar images

- Tender
- Composed
- Gentle

• This combination of dull tones and grayish tones possesses the gentleness of frosted glass. These soft tones are associated with an overall impression of chicness. The demand for these schemes ranges widely, from packaging to interior design.

• Because these impressions emphasize tone rather than hue changes, it is best to avoid strong lightness contrasts. However, as on page 24, using bright gray and beige maintains the composed ambience. On the other hand, when a sharp contrast is created using black, and so forth, the color scheme becomes modern and produces an Art Deco impression.

• On page 25, only natural colors are used. The color zone that includes the yellow group—yellow, orange, brown, beige, olive, and so on—is specifically designated the natural color zone. These colors are often used in similar-color color schemes or cognate-color color schemes. Since yellow is the common base, they harmonize well. These colors are called natural because they give an impression of something wilting, the smell of the earth, tree bark, and so on. Seasonally, it is a fall coloration.

Other references:
• Subdued (p. 56–57) • Solitary (p. 68–69)
• Dry (p. 70–71) • Chic (p. 84–87)
• Japanese Style (p. 88–93) • Autumn (p. 100)

97

A	Y30 M10 C30
B	Y30 M10 C10
C	Y30 M30 C10
D	Y10 M30 C30

98

A	Y10 M20 C30
B	Y30 M10 C10
C	Y10 M30 C10
D	Y20 M30 C30

99

A	Y30 M10 C20
B	Y30 M10 C10
C	Y20 M30 C10
D	Y30 M20 C30

100

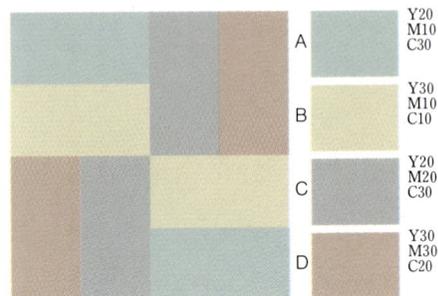

A	Y20 M10 C30
B	Y30 M10 C10
C	Y20 M20 C30
D	Y30 M30 C20

101

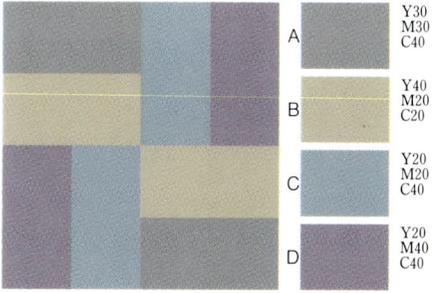

A — Y30 M30 C40
B — Y40 M20 C20
C — Y20 M20 C40
D — Y20 M40 C40

102

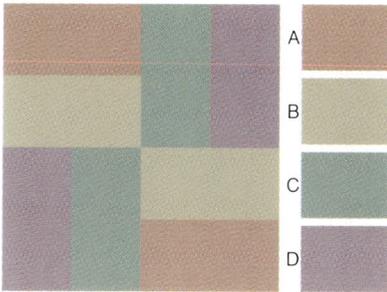

A — Y40 M40 C20
B — Y40 M20 C20
C — Y40 M20 C40
D — Y20 M40 C30

103

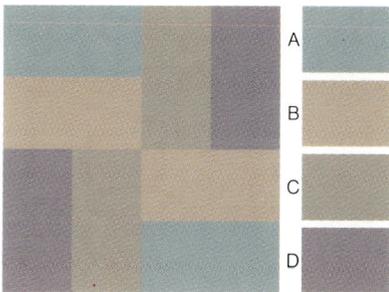

A — Y30 M20 C40
B — Y40 M30 C20
C — Y40 M30 C30
D — Y30 M40 C40

104

A — Y40 M40 C30
B — Y40 M30 C20
C — Y20 M40 C30
D — Y20 M40 C40

105

A — Y20 M20 C40
B — Y10 M30 C20
C — Y30 M20 C40
D — Y40 M40 C40

106

A — Y20 M30 C40
B — Y10 M30 C20
C — Y30 M40 C30
D — Y30 M40 C40

107

A — Y40 M40 C40
B — Y10 M20 C30
C — Y40 M30 C20
D — Y40 M20 C40

108

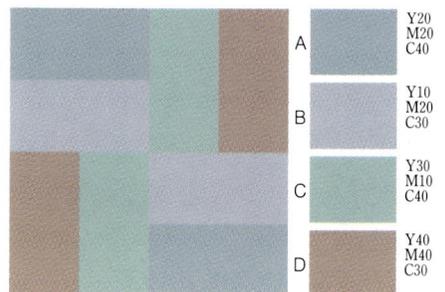

A — Y20 M20 C40
B — Y10 M20 C30
C — Y30 M10 C40
D — Y40 M40 C30

109

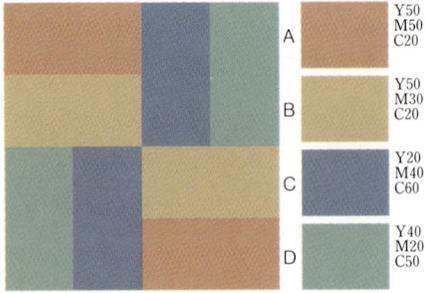

A — Y50 M50 C20
B — Y50 M30 C20
C — Y20 M40 C60
D — Y40 M20 C50

113

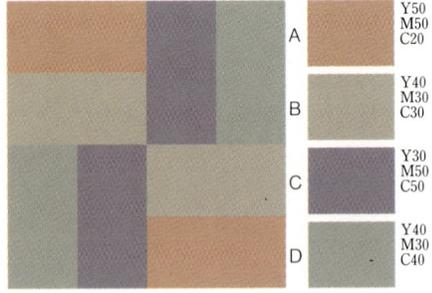

A — Y50 M50 C20
B — Y40 M30 C30
C — Y30 M50 C50
D — Y40 M30 C40

110

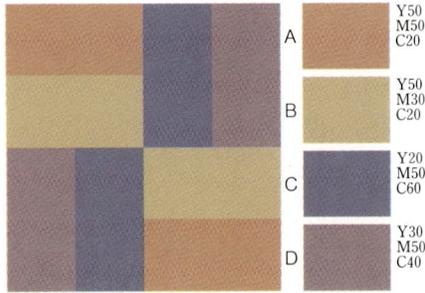

A — Y50 M50 C20
B — Y50 M30 C20
C — Y20 M50 C60
D — Y30 M50 C40

114

A — Y50 M50 C20
B — Y40 M30 C30
C — Y20 M40 C50
D — Y60 M50 C40

111

A — Y20 M50 C30
B — Y50 M30 C20
C — Y30 M30 C50
D — Y30 M10 C50

115

A — Y40 M50 C20
B — Y40 M30 C30
C — Y20 M50 C50
D — Y30 M30 C50

112

A — Y30 M30 C60
B — Y50 M30 C20
C — Y30 M50 C50
D — Y20 M30 C40

116

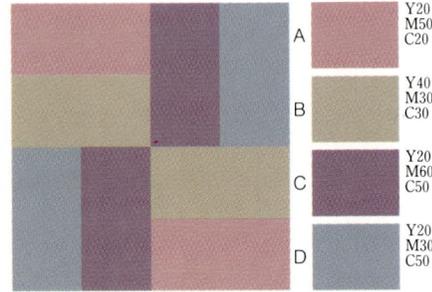

A — Y20 M50 C20
B — Y40 M30 C30
C — Y20 M60 C50
D — Y20 M30 C50

117

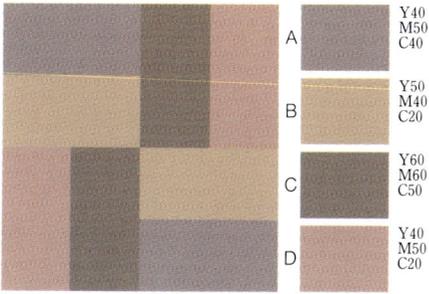

A — Y40 M50 C40
B — Y50 M40 C20
C — Y60 M60 C50
D — Y40 M50 C20

121

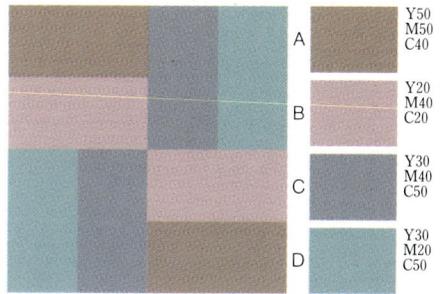

A — Y50 M50 C40
B — Y20 M40 C20
C — Y30 M40 C50
D — Y30 M20 C50

118

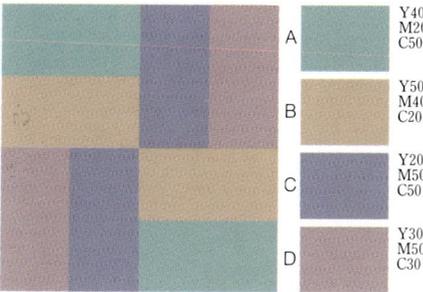

A — Y40 M20 C50
B — Y50 M40 C20
C — Y20 M50 C50
D — Y30 M50 C30

122

A — Y20 M50 C50
B — Y20 M40 C20
C — Y20 M50 C60
D — Y20 M30 C40

119

A — Y40 M50 C20
B — Y30 M40 C20
C — Y20 M50 C60
D — Y30 M30 C60

123

A — Y30 M40 C60
B — Y20 M30 C50
C — Y30 M50 C50
D — Y30 M40 C30

120

A — Y60 M50 C40
B — Y30 M40 C20
C — Y30 M50 C50
D — Y40 M50 C20

124

A — Y30 M50 C60
B — Y20 M30 C50
C — Y30 M40 C60
D — Y30 M20 C50

125

A	Y70 M70 C30
B	Y60 M30 C20
C	Y30 M70 C70
D	Y40 M30 C70

129

A	Y60 M30 C70
B	Y70 M50 C20
C	Y30 M70 C80
D	Y30 M70 C40

126

A	Y70 M60 C20
B	Y60 M30 C20
C	Y30 M50 C70
D	Y30 M70 C40

130

A	Y30 M70 C50
B	Y70 M50 C20
C	Y30 M70 C80
D	Y40 M30 C80

127

A	Y30 M70 C40
B	Y70 M40 C20
C	Y30 M40 C80
D	Y30 M70 C60

131

A	Y40 M70 C50
B	Y70 M70 C30
C	Y80 M70 C70
D	Y70 M50 C30

128

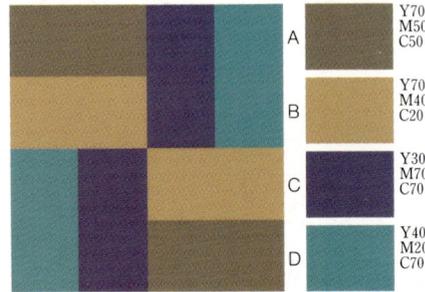

A	Y70 M50 C50
B	Y70 M40 C20
C	Y30 M70 C70
D	Y40 M20 C70

132

A	Y40 M40 C80
B	Y70 M70 C30
C	Y40 M60 C80
D	Y30 M40 C60

133

A — Y70 M60 C20
B — Y40 M80 C30
C — Y30 M60 C70
D — Y40 M30 C40

137

A — Y40 M30 C40
B — Y30 M40 C80
C — Y80 M70 C70
D — Y50 M70 C30

134

A — Y40 M50 C80
B — Y40 M80 C30
C — Y30 M50 C70
D — Y30 M30 C50

138

A — Y40 M40 C40
B — Y30 M40 C80
C — Y30 M60 C70
D — Y30 M70 C30

135

A — Y30 M70 C40
B — Y30 M70 C60
C — Y80 M70 C70
D — Y60 M50 C30

139

A — Y60 M70 C30
B — Y70 M30 C80
C — Y80 M70 C70
D — Y70 M60 C30

136

A — Y70 M60 C30
B — Y30 M70 C60
C — Y40 M30 C80
D — Y40 M30 C40

140

A — Y30 M70 C50
B — Y70 M30 C80
C — M30 M70 C70
D — Y40 M40 C40

141

A — Y80 M50 C20
B — Y50 M20 C20
C — Y80 M40 C80
D — Y40 M30 C20

145

A — Y80 M70 C20
B — Y30 M30 C30
C — Y40 M80 C40
D — Y30 M30 C50

142

A — Y80 M80 C20
B — Y50 M20 C20
C — Y50 M20 C80
D — Y40 M30 C20

146

A — Y80 M80 C20
B — Y30 M30 C30
C — Y40 M70 C80
D — Y30 M30 C50

143

A — Y80 M80 C20
B — Y50 M20 C20
C — Y50 M50 C80
D — Y30 M30 C40

147

A — Y30 M70 C40
B — Y30 M30 C30
C — Y40 M30 C80
D — Y40 M30 C40

144

A — Y30 M70 C80
B — Y50 M20 C20
C — Y30 M70 C40
D — Y30 M30 C40

148

A — Y50 M40 C80
B — Y30 M30 C30
C — Y40 M70 C80
D — Y40 M30 C40

149

A Y50 M60 C20
B Y40 M20 C20
C Y50 M30 C50
D Y50 M40 C20

153

A Y70 M70 C30
B Y50 M30 C20
C Y80 M70 C60
D Y70 M50 C20

150

A Y70 M70 C20
B Y40 M30 C30
C Y60 M50 C50
D Y70 M40 C20

154

A Y80 M80 C20
B Y70 M30 C40
C Y70 M60 C60
D Y70 M60 C20

151

A Y50 M30 C50
B Y40 M30 C10
C Y70 M70 C50
D Y60 M30 C20

155

A Y70 M60 C50
B Y70 M50 C20
C Y60 M50 C80
D Y70 M70 C20

152

A Y60 M50 C60
B Y50 M20 C20
C Y60 M50 C50
D Y50 M30 C30

156

A Y70 M50 C20
B Y60 M20 C40
C Y80 M50 C70
D Y80 M70 C20

FRUITY & JUICY

Similar images

- Sweet
- Warm
- Candy–like
- Tropical

• These images are of ripe and juicy fruits, permeated with flavors both sweet and sour, and suggestive of tropical climes. The impression is also of fancy sweets, such as berry-flavored or lemon-flavored candies.

• Bright tones are arrayed together, but they are not as strong as vivid tones. Hues mostly consist of colors that include yellow: orange, yellow, and green. Stimulating our sense of taste, these colors remind us of juices made from ripe fruits and tasty-looking honey-colored foods.

• To express a fresh quality, clear colors with a hint of transparency are usually employed. When a small amount of an unclear coloration, such as one of the browns, is added, a thickish taste is created. In general, the intention of this scheme is to combine sweet colors, such as orange and pink, and sour-tasting colors, such as yellow and green.

Other references:
• Tropical (p. 28–29) • Spring (p. 97)

157

A Y80 M70
B M80 C50
C Y80 M30
D Y80 C80

158

A Y80 M40
B Y20 M80
C M70 C70
D Y70 M10

159

A Y80 C60
B M80 C40
C Y80 M50
D Y80 C20

160

A Y60 M80
B Y80 C30
C Y50 C80
D Y80 M50

161

A	Y10 M80
B	M60 C70
C	Y80 M50 C50
D	Y80 M40

165

A	Y40 M80
B	Y80 M40
C	Y80 M70 C20
D	Y80 M30 C70

162

A	M80 C30
B	Y70 M80
C	Y80 M50 C30
D	Y20 M70

166

A	Y30 M70
B	Y80 C30
C	Y80 M50 C20
D	Y60 M70 C60

163

A	Y80 M50
B	M80 C60
C	Y80 M70 C60
D	Y80 M80

167

A	Y80 M60
B	Y50 M80
C	Y30 M80 C40
D	Y60 M50 C80

164

A	M80 C50
B	Y50 M80
C	Y80 M40 C60
D	Y80 M60

168

A	Y80 M80
B	M80 C50
C	Y80 M40 C80
D	Y80 M50 C20

TROPICAL

Similar images

- Casual
- Active
- Passionate
- Gay
- Ethnic

• Tropical refers to the vivid flowers, birds, and tropical fish found in the countries of the southern hemisphere. Another association is to a landscape filled with a multitude of colors. The ambience of this scheme is best created using numerous rhythmical shapes in many colors dispersed throughout the composition to avoid monotony. As in these examples, this scheme also involves techniques for composing colorful patterns against a ground.

• Without being overly concerned about hues, put opposing colors against the ground color, then add any other colors desired to complete the scheme. The feeling is "Let's enjoy ourselves!"

• When deep and dark are added, such as those on page 31, the atmosphere is both tropical and ethnic. These combinations are reminiscent of batik or folk art toys. The weightier the impression becomes, the more intensely the tropical heat is sensed. This tropical scheme is full-bodied throughout.

Other references:
- Fruity & Juicy (p. 26–27)
- Ethnic (p. 42–43) • Warm/Hot (p. 63)
- Exotic (p. 74–79) • Summer (p. 99)

169

A Y80
B Y80 C80
C M80 C70
D M80

170

A Y80 M20
B Y90 M80
C M80 C30
D Y20 C90

171

A Y80 M50
B M90 C20
C Y40 C90
D M80 C80

172

A Y90 M80
B Y80 M20
C M50 C90
D Y50 C90

173

A — Y30 M80
B — Y80 C80
C — M90 C80
D — Y80 M30

177

A — M40 C90
B — Y80 M10
C — Y90 M80
D — M90 C80

174

A — M80
B — Y80 M10
C — Y60 C80
D — M80 C60

178

A — Y40 C90
B — Y90 M50
C — M80 C80
D — Y20 M80

175

A — M80 C40
B — Y80 M50
C — M60 C90
D — Y80 C20

179

A — Y80 C90
B — Y80 M80
C — Y80 M20
D — M80 C40

176

A — M80 C80
B — Y30 C80
C — Y80 M20
D — Y90 M80

180

A — Y80 C20
B — M80 C50
C — Y90 M50
D — Y10 M80

181

A		Y100 M10
B		Y100 M90
C		Y100 C50
D		M100 C30

185

A		M100 C90
B		Y100 M70
C		Y100 C30
D		Y90 M100

182

A		Y100 M50
B		M100 C40
C		M80 C100
D		Y50 C100

186

A		Y10 C100
B		Y10 M100
C		Y100 M20
D		Y100 M70

183

A		Y100 M100
B		Y80 C100
C		Y100 M60
D		M100 C100

187

A		Y100 C100
B		Y100 M90
C		M100 C20
D		M100 C70

184

A		Y10 M100
B		Y30 C100
C		M100 C80
D		Y100 M60

188

A		Y100 C20
B		Y10 M100
C		Y100 M60
D		M100 C80

189

A — Y100 M40
B — M100 C30
C — Y100 M80 C70
D — Y100 M90

193

A — Y100 M40 C20
B — M100
C — M100 C80
D — Y60 C100

190

A — Y90 M100
B — Y100 M50
C — Y100 M60 C80
D — M100 C50

194

A — Y100 M70 C40
B — Y100 M40
C — M100 C100
D — Y20 C100

191

A — M90 C100
B — M100
C — Y100 M80 C60
D — Y50 C100

195

A — Y100 M80 C70
B — Y100 M50
C — Y100 M90
D — Y100 C30

192

A — Y100 C90
B — Y100 M90
C — Y100 M50 C40
D — M100 C90

196

A — Y100 M60 C80
B — Y100 M100
C — M100 C30
D — Y100 M60

STRONG

Similar images

- Vivid
- Gay
- Pop

• The expression of strength some-
times emphasizes contrasts in light-
ness values, such as black and
white. Here, however, strength is
given a structure through the use of
vivid color schemes of contrasting
hues. These color schemes are
strong and energetic, even when
they incorporate a few colors.
Because these colors are bold and
graphic, they are suitable for
symbolic use on posters and signs.
• Combinations of the most brilliant
and pure colors from among strong
colors and vivid tones are filled with
power. Creating a world where col-
ors clash together or where oppos-
ing colors emphasize each other is
the primary atttraction of this color
scheme.
• Vivid colors can be combined with
other deep or dark, or dull or gray-
ish schemes, but only very carefully
with pastels. In addition, the
strength of vivid colors can be more
effectively displayed when the
shapes and pattern divisions are
bold and simple.

Other references:
- Tropical (p. 30–31) • Sporty (p. 38–40)
- Ethnic (p. 42–43) • Warm/Hot (p. 63)
- Exotic (p. 74–79) • Summer (p. 99)

197

A	Y100 M10
B	Y100 M100
C	M80 C100
D	Y100 C100

198

A	Y100 M10
B	M100
C	M100 C90
D	Y50 C100

199

A	Y100 M10
B	M100 C90
C	Y100 M100
D	Y100 C100

200

A	Y100 M10
B	M90 C100
C	Y90 M100
D	M100 C60

201

A — Y100 M30
B — Y100 M90
C — M70 C100
D — Y80 C100

205

A — Y100 M70
B — M100 C30
C — Y90 M100
D — M90 C100

202

A — Y100 M30
B — M100
C — M100 C80
D — Y40 C100

206

A — Y100 M70
B — M100 C80
C — Y60 C100
D — Y100 M100

203

A — Y100 M30
B — M100 C20
C — Y50 C100
D — Y100 M100

207

A — Y100 M70
B — M100 C100
C — Y80 C100
D — Y90 M100

204

A — Y100 M30
B — M100 C100
C — Y90 M100
D — M60 C100

208

A — Y100 M70
B — Y80 C100
C — M100 C80
D — M100 C10

209

A — Y100 M100
B — Y100 M10
C — M100 C100
D — Y50 C100

213

A — M100
B — Y100
C — M100 C90
D — Y20 C100

210

A — Y100 M100
B — Y100 M50
C — M100 C30
D — M90 C100

214

A — M100
B — Y100 M30
C — M100 C100
D — Y80 C100

211

A — Y100 M100
B — M80 C100
C — Y100 M20
D — Y80 C100

215

A — M100
B — M90 C100
C — Y100 M50
D — Y60 C100

212

A — Y100 M100
B — Y100 C100
C — Y100 M60
D — M100 C80

216

A — M100
B — Y100 C100
C — M100 C100
D — Y90 M100

217

- A — M100 C30
- B — Y100 M20
- C — M100
- D — M100 C80

221

- A — M100 C90
- B — Y100 M10
- C — Y100 M70
- D — M100 C40

218

- A — M100 C30
- B — Y100 M40
- C — M100 C90
- D — Y100 M100

222

- A — M100 C90
- B — Y100 M40
- C — Y90 M100
- D — Y50 C100

219

- A — M100 C30
- B — Y90 M100
- C — Y100 M30
- D — Y60 C100

223

- A — M100 C90
- B — Y100 M100
- C — Y100 M10
- D — Y10 C100

220

- A — M100 C30
- B — Y100 C100
- C — Y100 M70
- D — M100 C100

224

- A — M100 C90
- B — Y80 C100
- C — Y100 M100
- D — Y100 M50

225

A	M70 C100
B	Y100 M20
C	Y90 M100
D	M100 C100

229

A	C100
B	Y100 M10
C	Y100 M100
D	M100 C100

226

A	M70 C100
B	Y100 M80
C	Y100 M50
D	M100 C30

230

A	C100
B	Y100 M30
C	Y90 M100
D	M100 C30

227

A	M70 C100
B	Y90 M100
C	Y80 C100
D	Y100 M40

231

A	C100
B	Y100 M100
C	M100 C90
D	Y100 M50

228

A	M70 C100
B	Y10 M100
C	Y100 M60
D	Y50 C100

232

A	C100
B	M100
C	Y100 M20
D	M90 C100

233

A Y50 C100
B Y100 M40
C M100 C30
D Y100 M100

237

A Y100 C100
B Y100 M10
C Y100 M100
D M80 C100

234

A Y50 C100
B Y90 M100
C Y100 M20
D M80 C100

238

A Y100 C100
B Y100 M80
C M100 C30
D M100 C100

235

A Y50 C100
B M100
C M100 C90
D Y100 M70

239

A Y100 C100
B M100
C M100 C90
D Y10 C100

236

A Y50 C100
B M100 C80
C Y90 M100
D Y100 M50

240

A Y100 C100
B M100 C90
C Y100 M50
D Y100 M100

SPORTY

Similar images

- Robust
- Lively
- Rhythmic

• Brilliant, vivid tones possessing a clear-cut assertiveness impart a sense of activity and robustness. Robust reds, youthful yellows and oranges, and healthful greens, in particular, make us feel energetic. Clear contrasts, such as yellow/blue and red/green, generate a liveliness associated with a sporty image.

• Using white is an essential technique for giving a lively impression. When showy colors are used, the scheme often becomes too aggressive or even suffocating. But with the addition of white, jarring colors are instantly coordinated and become rhythmic.

• Deep and dark tones are not in themselves sporty, but using white with them as a lightness contrast creates a sense of liveliness and an impression of "personality." When gray is added, the impression is one of sporty elegance.

Other references:
- Refreshing (p. 14–15)
- Lighthearted (p. 16–17)
- Tropical (p. 28–30)
- Strong (p. 32–37)
- Elegant (p. 81)
- Summer (p. 98–99)

241

A Y100
B M10 C100
C M80 C100
D Y10 M100

242

A Y100
B M100 C30
C Y30 C100
D M80 C100

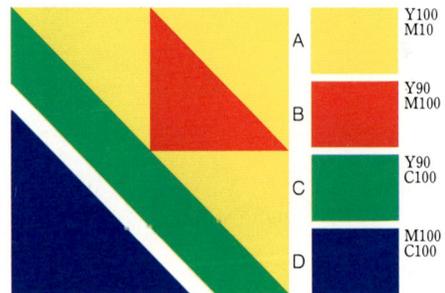

243

A Y100 M10
B Y90 M100
C Y90 C100
D M100 C100

244

A Y100 M10
B M100 C90
C M100 C40
D Y60 C100

245

A — Y100 M30

B — M80 C100

C — M30 C100

D — M100 C90

249

A — M10 C100

B — Y100

C — Y100 M70

D — Y80 C100

246

A — Y100 M30

B — M100 C30

C — Y80 C100

D — M90 C100

250

A — Y40 C100

B — Y100 M20

C — M90 C100

D — Y60 C100

247

A — Y100 M40

B — Y10 M100

C — M80 C100

D — Y20 C100

251

A — Y20 C100

B — M100 C90

C — M100

D — Y80 C100

248

A — Y100 M40

B — M90 C100

C — M100 C50

D — Y90 M100

252

A — M100 C90

B — M10 C100

C — Y90 C100

D — Y90 M100

253

A Y100
 M10

B M100
 C90

C Y100
 M80
 C60
 BL40

D Y30
 C100

257

A Y100
 M20

B Y30
 M100
 C100

C M100

D Y100
 M80
 C70
 BL40

254

A M100
 C90

B Y90
 M100

C Y60
 M30
 C100
 BL40

D M100
 C40

258

A Y90
 M100

B Y80
 M50
 C100

C M100
 C70

D Y20
 M90
 C100
 BL30

255

A Y10
 C100

B Y100
 M60

C Y20
 M100
 C100
 BL30

D Y60
 C100

259

A M100
 C30

B Y60
 M60
 C100

C Y100
 M40

D Y20
 M100
 C70
 BL30

256

A Y30
 C100

B M100
 C30

C Y100
 M50
 C20

D M100
 C100

260

A M70
 C100

B Y100
 M30
 C20

C Y40
 C100

D Y70
 M100
 C30
 BL50

261

A	Y90 M100
B	Y60 C100
C	Y30 M20 C30 BL20
D	Y30 M100 C100

265

A	Y30 M20 C30 BL40
B	Y100 M30
C	M90 C100
D	Y70 M50 C100

262

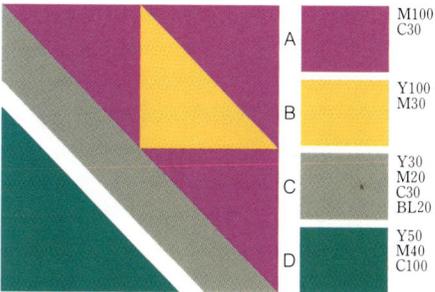

A	M100 C30
B	Y100 M30
C	Y30 M20 C30 BL20
D	Y50 M40 C100

266

A	Y30 M20 C30 BL40
B	Y100 M80
C	Y80 C100
D	Y20 M100 C50

263

A	M100 C70
B	Y20 C100
C	Y30 M20 C30 BL20
D	Y20 M100 C30

267

A	Y30 M20 C30 BL40
B	Y30 M100
C	M100 C90
D	Y50 M30 C100

264

A	M100 C100
B	Y100 M20
C	Y30 M20 C30 BL20
D	Y80 M30 C100

268

A	Y30 M20 C30 BL40
B	M70 C100
C	Y20 C100
D	Y30 M80 C100

ETHNIC

Similar images

- Hot
- Dense
- Southern

• Ethnic suggests the traditions of non-Western cultures, especially of southern peoples. Leaning toward full-bodied tones, these colors are derived from natural sources, such as the intense primary colors of tropical areas and dyes made from the earth and grass. Folk clothing from different countries is the best source from which to draw this color image.

• In the first half of the following examples, vivid tones are mainly used; in the second half, deep and dark tones. In the Vivid + Deep, Dark section, numbers 277 and 278 are examples of night color schemes (see page 112). The ethnic color scheme is easy to understand when it is seen to be a kind of exotic color scheme, such as those formed by intense primary colors and in mysterious night color schemes. Natural colors such as khaki, brown, and sepia are the representative colors for ethnic color schemes because heat can be expressed by combining them with the primaries.

• When the color scheme is arranged only according to deeps and darks, the scheme possesses a hint of natural earth dyes.

Other references:
- Tropical (p. 31) • Full-bodied (p. 46–51)
- Dark (p. 52–55) • Exotic (p. 74–79)
- Japanese Style (p. 88–95) • Autumn (p. 101)

269

A — Y100 M30
B — M100 C90
C — Y100 M100 C30
D — Y100 M70 C80

270

A — Y100 M30
B — Y100 M80 C70 BL20
C — Y40 C100
D — M100 C30

271

A — Y100 M100
B — Y100 M30 C20
C — Y80 M30 C100
D — Y100 M80 C70 BL20

272

A — Y100 M100
B — Y100 M50 C20
C — M100 C30
D — Y40 M100 C100

273

A	M100 C20
B	Y50 M70 C100 BL30
C	Y100 M50 C20
D	Y100 M100

277

A	Y50 C100
B	M100 C100
C	Y100 M50 C20
D	Y100 M70 C50 BL40

274

A	M100 C20
B	Y100 M60 C20
C	Y50 M30 C100
D	M100 C90

278

A	Y50 C100
B	Y100 M60 C20
C	M100 C50
D	Y100 M80 C70 BL50

275

A	M100 C90
B	Y100 M70
C	Y100 M70 C60
D	Y80 M100 C30

279

A	Y100 C100
B	Y100 M70
C	Y20 M100 C40
D	Y100 M70 C70 BL30

276

A	M100 C90
B	Y100 M80 C70 BL30
C	Y100 M50 C50
D	Y70 M100

280

A	Y100 C100
B	Y100 M50 C20
C	Y100 M90 C60 BL20
D	M100 C90

281

A — Y100 M30 C20
B — Y100 M100 C40
C — Y100 M70 C80
D — Y100 M80 C70 BL30

285

A — Y100 M80 C40
B — Y40 M70 C100 BL20
C — Y100 M60 C20
D — Y90 M100 C30

282

A — Y100 M30 C20
B — Y100 M70 C30
C — Y30 M100 C50
D — Y40 M70 C100 BL20

286

A — Y100 M80 C40
B — Y100 M60 C70
C — Y100 M70 C20
D — Y50 M70 C100 BL30

283

A — Y100 M70 C20
B — Y100 M30 C20
C — Y100 M60 C90
D — Y100 M80 C70 BL20

287

A — Y70 M100 C30
B — Y20 M100 C90
C — Y100 M30 C40
D — Y100 M70 C20

284

A — Y100 M70 C20
B — Y100 M80 C50
C — Y30 M100 C70
D — Y40 M100 C100 BL20

288

A — Y70 M100 C30
B — Y30 M100 C40
C — Y100 M60 C20
D — Y80 M70 C100 BL20

289

A Y20
 M100
 C40

B Y80
 M70
 C100
 BL20

C Y100
 M30
 C20

D Y100
 M90
 C30

293

A Y50
 M70
 C100

B Y20
 M100
 C100

C Y100
 M40
 C20

D Y100
 M90
 C40

290

A Y20
 M100
 C40

B Y40
 M100
 C100
 BL20

C Y100
 M60
 C20

D Y100
 M80
 C60
 BL30

294

A Y50
 M70
 C100

B Y100
 M90
 C40
 BL50

C Y100
 M70
 C20

D Y100
 M80
 C50

291

A Y50
 M100
 C100

B Y100
 M80
 C80
 BL20

C Y100
 M70
 C20

D Y90
 M100
 C30

295

A Y100
 M50
 C90

B Y30
 M100
 C60

C Y100
 M30
 C20

D Y100
 M100
 C30

292

A Y50
 M100
 C100

B Y30
 M100
 C50
 BL20

C Y100
 M30
 C20

D Y100
 M60
 C20

296

A Y100
 M50
 C90

B Y100
 M100
 C40

C Y100
 M70
 C30

D Y40
 M70
 C100
 BL20

FULL-BODIED

Similar images

- Lustrous
- Autumnal
- Ethnic
- Mature

• This sphere of colors consists of deep tones whose depth has increased in vividness. While vividness creates an impression of summer and of the energy of the natural world, it is essentially the image of autumn, of rich abundance and ripe fertility. These schemes have a quietly calm, mature atmosphere, yet retain a bit of bright sparkle. Jewelry tones such as ruby and sapphire also combine vividness with deepness.

• When yellows are frequently used, as in the examples on pages 46 and 47, there is a strong impression of an autumn evening with a glowing, waning sun. With an increase in cold colors, as on page 51, there is an atmosphere of mystery, as if revealing the heart of the deep and quiet ocean.

• These color schemes consist of deep tones. Darks can be used because both deeps and darks are full-bodied tones. Pastels, because of their innocence, clash with the maturity of the deep tones and therefore should be selected judiciously.

Other references:
- Ethnic (p. 44–45) • Dark (p. 52–55)
- Folk Craft (p. 94–95)
- Autumn (p. 101)

297

A — Y100 M40 C20
B — Y100 M60 C20
C — Y100 M40 C70
D — Y100 M90 C30

298

A — Y100 M40 C20
B — Y100 M70 C20
C — Y20 M100 C90
D — Y100 M90 C40

299

A — Y100 M40 C20
B — Y100 M90 C20
C — Y20 M100 C70
D — Y30 M80 C100 BL20

300

A — Y100 M40 C20
B — Y100 M90 C20
C — Y50 M100 C50
D — Y20 M100 C70 BL30

301

A — Y100 M40 C20
B — Y90 M100 C30
C — Y100 M70 C50
D — Y20 M100 C70

305

A — Y100 M40 C20
B — Y90 M100 C30
C — Y80 M40 C100
D — Y100 M80 C50 BL20

302

A — Y100 M40 C20
B — Y90 M100 C30
C — Y100 M30 C70
D — Y100 M60 C70 BL20

306

A — Y100 M40 C20
B — Y90 M100 C30
C — Y50 M50 C100
D — Y20 M100 C80

303

A — Y100 M40 C20
B — Y90 M100 C30
C — Y100 M40 C100
D — Y20 M100 C100 BL20

307

A — Y100 M40 C20
B — Y90 M100 C30
C — Y30 M100 C70
D — Y50 M100 C50

304

A — Y100 M40 C20
B — Y90 M100 C30
C — Y80 M40 C100
D — Y20 M100 C70

308

A — Y100 M40 C20
B — Y90 M100 C30
C — Y30 M100 C60
D — Y40 M100 C100

309

A	Y100 M40 C20
B	Y50 M100 C50
C	Y100 M80 C40
D	Y20 M100 C90

313

A	Y100 M40 C20
B	Y60 M50 C100
C	Y20 M100 C50
D	Y20 M100 C100

310

A	Y100 M40 C20
B	Y50 M100 C50
C	Y20 M100 C70
D	Y20 M90 C100 BL20

314

A	Y100 M40 C20
B	Y60 M50 C100
C	Y20 M100 C70
D	Y30 M90 C100 BL20

311

A	Y100 M40 C20
B	Y50 M100 C50
C	Y50 M50 C100
D	Y30 M100 C90 BL20

315

A	Y100 M40 C20
B	Y60 M50 C100
C	Y100 M80 C60
D	Y30 M100 C100 BL20

312

A	Y100 M40 C20
B	Y50 M100 C50
C	Y80 M40 C100
D	Y20 M100 C80

316

A	Y100 M40 C20
B	Y60 M50 C100
C	Y100 M70 C50 BL20
D	Y20 M100 C70

317

A	Y100 M60 C20
B	Y40 M100 C30
C	Y100 M80 C60
D	Y30 M100 C70

321

A	Y100 M60 C20
B	Y40 M80 C100
C	Y100 M40 C90
D	Y50 M100 C60

318

A	Y100 M60 C20
B	Y20 M100 C50
C	Y50 M100 C70
D	Y30 M100 C100

322

A	Y100 M60 C20
B	Y40 M80 C100
C	Y100 M30 C100
D	Y30 M100 C70

319

A	Y100 M60 C20
B	Y20 M100 C70
C	Y40 M100 C20
D	Y20 M90 C100 BL20

323

A	Y100 M60 C20
B	Y70 M40 C100
C	Y90 M100 C30
D	Y20 M100 C100

320

A	Y100 M60 C20
B	Y20 M100 C90
C	Y100 M90 C30
D	Y100 M50 C100

324

A	Y100 M60 C20
B	Y70 M40 C100
C	Y30 M100 C70
D	Y30 M90 C100 BL20

325

A	Y90 M100 C30
B	Y30 M100 C60
C	Y100 M50 C30
D	Y80 M40 C100

329

A	Y30 M100 C30
B	Y100 M80 C70
C	Y20 M100 C100
D	Y100 M40 C100

326

A	Y90 M100 C30
B	Y30 M100 C80
C	Y50 M100 C50
D	Y40 M80 C100 BL20

330

A	Y30 M100 C30
B	Y30 M100 C50
C	Y50 M50 C100
D	Y20 M90 C100 BL20

327

A	Y90 M100 C30
B	Y20 M100 C100
C	Y30 M100 C70
D	Y100 M50 C100

331

A	Y30 M100 C30
B	Y20 M100 C70
C	Y30 M80 C100
D	Y20 M100 C100 BL20

328

A	Y90 M100 C30
B	Y70 M40 C100
C	Y20 M100 C70
D	Y30 M80 C100 BL20

332

A	Y30 M100 C30
B	Y20 M100 C90
C	Y70 M30 C100
D	Y100 M60 C40

333

A　Y30 M100 C60

B　Y30 M80 C100

C　Y100 M60 C70

D　Y40 M30 C100

337

A　Y30 M100 C90

B　Y50 M50 C100

C　Y100 M70 C100

D　Y100 M60 C50 BL30

334

A　Y30 M100 C60

B　Y50 M40 C100

C　Y40 M100 C100 BL20

D　Y30 M100 C90

338

A　Y30 M100 C90

B　Y50 M50 C100

C　Y40 M80 C100

D　Y100 M30 C90

335

A　Y30 M100 C60

B　Y80 M40 C100

C　Y30 M100 C100

D　Y100 M80 C50 BL20

339

A　Y30 M100 C90

B　Y80 M40 C100

C　Y20 M100 C100 BL20

D　Y30 M100 C70

336

A　Y30 M100 C60

B　Y100 M30 C100

C　Y30 M100 C100

D　Y50 M40 C100 BL20

340

A　Y30 M100 C90

B　Y80 M40 C100

C　Y70 M100 C60

D　Y100 M80 C100 BL20

51

DARK

Similar images

- Serious
- Classic
- Full-bodied

• When color schemes are organized with these spirited dark tones, a somewhat serious and stylized world can be developed. Seasonally, the classic and noble tones suggest autumn and winter.

• Color schemes using dark colors display subtle color tones throughout, even though the shapes may be barely discernible. It is better not to add bright colors to this scheme without first considering the effect. Simple as well as complex shapes that fill up the entire color field—ethnic designs, for instance—would be successful. From a distance, such a scheme might appear dark, but upon close inspection reveals an elaborate, complex pattern. This technique is often used in weaving.

• On the other hand, when shape is clearly displayed, the color scheme can be created by applying relatively light colors to the ground (also acceptable to apply to the pattern) or by dividing the shape into two large sections and contrasting the colors using opposing hues. In either case, it always is important to arrange the color scheme by thinking about the total ambience instead of concentrating only on the details.

Other references:
• Subdued (p. 58–61)

341

A Y100 M40 C20 BL60
B Y100 M90 C30 BL60
C Y100 M80 C20 BL40
D Y100 M90 C60 BL70

342

A Y100 M40 C20 BL60
B Y40 M100 C40 BL60
C Y100 M80 C50 BL40
D Y20 M100 C70 BL60

343

A Y100 M40 C20 BL60
B Y100 M90 C60 BL70
C Y100 M90 C30 BL60
D Y30 M100 C90 BL80

344

A Y100 M40 C20 BL60
B Y50 M100 C40 BL50
C Y100 M80 C20 BL40
D Y30 M80 C100 BL60

345

A — Y100 M40 C20 BL60
B — Y40 M100 C40 BL60
C — Y100 M80 C50 BL60
D — Y100 M50 C100 BL70

349

A — Y100 M60 C20 BL50
B — Y100 M90 C60 BL60
C — Y30 M80 C100 BL40
D — Y30 M80 C100 BL70

346

A — Y100 M40 C20 BL60
B — Y50 M30 C100 BL60
C — Y100 M90 C30 BL60
D — Y30 M100 C90 BL70

350

A — Y100 M60 C20 BL50
B — Y40 M100 C40 BL60
C — Y100 M50 C80 BL50
D — Y30 M100 C100 BL60

347

A — Y100 M40 C20 BL60
B — Y50 M50 C100 BL60
C — Y40 M100 C40 BL50
D — Y100 M90 C60 BL60

351

A — Y100 M60 C20 BL50
B — Y20 M100 C70 BL50
C — Y100 M90 C30 BL40
D — Y30 M100 C90 BL70

348

A — Y100 M40 C20 BL60
B — Y100 M50 C100 BL70
C — Y50 M100 C40 BL60
D — Y30 M100 C90 BL70

352

A — Y100 M60 C20 BL50
B — Y40 M50 C100 BL70
C — Y20 M100 C60 BL50
D — Y30 M100 C90 BL70

353

A	Y100 M80 C20 BL40
B	Y100 M60 C50 BL50
C	Y100 M100 C40 BL50
D	Y50 M100 C40 BL70

357

A	Y100 M90 C60 BL60
B	Y100 M40 C60 BL50
C	Y100 M60 C30 BL60
D	Y30 M80 C100 BL70

354

A	Y100 M80 C20 BL40
B	Y40 M100 C40 BL60
C	Y100 M50 C100 BL70
D	Y100 M90 C60 BL70

358

A	Y100 M90 C60 BL60
B	Y30 M100 C40 BL60
C	Y100 M50 C20 BL50
D	Y50 M50 C100 BL60

355

A	Y100 M90 C20 BL50
B	Y20 M100 C100 BL50
C	Y20 M100 C70 BL50
D	Y100 M90 C60 BL60

359

A	Y40 M100 C40 BL50
B	Y100 M90 C60 BL60
C	Y30 M80 C100 BL60
D	Y60 M30 C100 BL70

356

A	Y100 M90 C20 BL50
B	Y40 M80 C100 BL60
C	Y100 M60 C20 BL50
D	Y40 M100 C30 BL60

360

A	Y40 M100 C40 BL50
B	Y50 M50 C100 BL60
C	Y100 M60 C30 BL60
D	Y30 M100 C90 BL70

361

A	Y30 M100 C90 BL70
B	Y100 M90 C30 BL60
C	Y100 M50 C30 BL50
D	Y80 M50 C100 BL70

365

A	Y60 M30 C100 BL60
B	Y80 M100 C40 BL50
C	Y100 M60 C30 BL50
D	Y30 M80 C100 BL70

362

A	Y30 M100 C90 BL70
B	Y50 M100 C50 BL60
C	Y100 M80 C30 BL50
D	Y100 M90 C60 BL70

366

A	Y60 M30 C100 BL60
B	Y20 M100 C40 BL60
C	Y100 M90 C30 BL40
D	Y100 M90 C60 BL70

363

A	Y30 M80 C100 BL50
B	Y100 M60 C30 BL60
C	Y100 M90 C20 BL50
D	Y30 M100 C100 BL70

367

A	Y100 M50 C100 BL60
B	Y90 M100 C40 BL50
C	Y100 M80 C50 BL30
D	Y30 M80 C100 BL70

364

A	Y30 M80 C100 BL50
B	Y80 M50 C100 BL50
C	Y60 M100 C30 BL60
D	Y20 M100 C90 BL70

368

A	Y100 M50 C100 BL60
B	Y30 M100 C70 BL60
C	Y80 M100 C40 BL60
D	Y30 M100 C100 BL70

SUBDUED
Similar images

- Simple
- Quiet
- Solitary

• With respect to tone, subdued is dull and grayish. But subdued also encompasses pale and dark tones. When the difference in lightness of the colors to be combined is small, a somewhat dispirited feeling is generated. Instead of subdued, the feeling is close to solitary. On the other hand, when the difference in lightness is clearly delineated, even though the total impression is subdued, the clear-cut contrast makes the scheme seem stylish and chic.

• In terms of hue, when the color scheme is arranged mainly with warm colors and browns, it softens and takes on a naturalistic feel. Even though this kind of color scheme is common, it creates an impression of Japanese style and of composedness. When arranged with cold colors, this color scheme evokes a shivery, chilly impression suggestive of a winter's sky.

• Even with grayish tones, colors opposite in hue still make the color scheme stand out. If an impression of quiet coloring is desired, similar-color and cognate-color color schemes are effective. The tones in this area also have a strong classic image, but can be made more modern by clearly distinguishing between lightness values or by using black.

Other references:
• Solitary (p. 68–69) • Chic (p. 86–87)
• Winter (p. 103)

56

369

A	Y30 M20 C20 BL20
B	Y40 M30 C30 BL30
C	Y50 M40 C40 BL30
D	Y60 M50 C40 BL50

370

A	Y30 M20 C20 BL20
B	Y30 M30 C50 BL30
C	Y20 M50 C50 BL30
D	Y30 M50 C70 BL50

371

A	Y30 M20 C10 BL20
B	Y40 M40 C30 BL30
C	Y20 M50 C40 BL30
D	Y40 M60 C40 BL50

372

A	Y30 M20 C10 BL20
B	Y40 M30 C40 BL30
C	Y60 M50 C40 BL40
D	Y40 M40 C70 BL50

373

A	Y20 M20 C10 BL20
B	Y40 M30 C30 BL30
C	Y30 M40 C30 BL40
D	Y50 M50 C50 BL40

377

A	Y10 M10 C30 BL20
B	Y40 M30 C30 BL30
C	Y40 M40 C30 BL40
D	Y40 M40 C70 BL60

374

A	Y20 M20 C10 BL20
B	Y20 M50 C40 BL30
C	Y20 M30 C50 BL40
D	Y50 M50 C70 BL50

378

A	Y10 M10 C30 BL20
B	Y20 M30 C50 BL30
C	Y30 M50 C40 BL40
D	Y40 M60 C70 BL60

375

A	Y10 M20 C20 BL20
B	Y30 M50 C40 BL30
C	Y30 M40 C50 BL40
D	Y30 M60 C50 BL60

379

A	Y20 M10 C30 BL20
B	Y50 M30 M30 BL30
C	Y40 M30 C30 BL40
D	Y30 M60 C50 BL60

376

A	Y10 M20 C20 BL20
B	Y40 M30 C30 BL30
C	Y30 M40 C50 BL50
D	Y30 M70 C70 BL60

380

A	Y20 M10 C30 BL20
B	Y20 M30 C50 BL30
C	Y20 M50 C50 BL30
D	Y30 M50 C70 BL60

381

A Y50 M30 C30 BL30
B Y50 M50 C50 BL40
C Y60 M40 C60 BL50
D Y60 M50 C40 BL70

385

A Y40 M40 C30 BL30
B Y20 M50 C40 BL40
C Y30 M70 C70 BL40
D Y30 M60 C60 BL60

382

A Y50 M30 C30 BL30
B Y30 M50 C50 BL40
C Y50 M40 C60 BL40
D Y30 M50 C70 BL70

386

A Y40 M40 C30 BL30
B Y40 M40 C60 BL40
C Y50 M70 C50 BL50
D Y40 M40 C70 BL70

383

A Y50 M40 C30 BL30
B Y50 M50 C50 BL40
C Y30 M50 C70 BL40
D Y70 M70 C40 BL70

387

A Y30 M40 C30 BL30
B Y50 M50 C30 BL40
C Y50 M50 C70 BL40
D Y70 M70 C50 BL70

384

A Y50 M40 C30 BL30
B Y30 M40 C50 BL40
C Y30 M60 C50 BL40
D Y30 M60 C50 BL70

388

A Y30 M40 C30 BL30
B Y50 M40 C60 BL40
C Y30 M50 C60 BL50
D Y30 M60 C60 BL70

389

A Y30 M40 C40 BL30
B Y50 M40 C30 BL40
C Y50 M60 C40 BL40
D Y30 M60 C70 BL60

393

A Y30 M20 C50 BL30
B Y60 M50 C40 BL50
C Y30 M60 C50 BL50
D Y40 M40 C70 BL70

390

A Y30 M40 C40 BL30
B Y30 M50 C70 BL40
C Y30 M60 C70 BL50
D Y30 M60 C60 BL70

394

A Y30 M20 C50 BL30
B Y30 M50 C40 BL60
C Y40 M50 C60 BL60
D Y40 M70 C70 BL70

391

A Y20 M30 C50 BL30
B Y50 M50 C50 BL40
C Y40 M50 C70 BL40
D Y50 M70 C50 BL60

395

A Y50 M30 C50 BL30
B Y60 M40 C40 BL50
C Y60 M40 C70 BL60
D Y60 M60 C30 BL70

392

A Y20 M30 C50 BL30
B Y20 M50 C30 BL50
C Y30 M70 C50 BL40
D Y30 M70 C70 BL60

396

A Y50 M30 C50 BL30
B Y40 M40 C70 BL50
C Y30 M60 C50 BL60
D Y30 M50 C70 BL70

397

A | Y70
M40
C30
BL70

B | Y50
M50
C40
BL40

C | Y50
M40
C40
BL50

D | Y30
M30
C10
BL20

401

A | Y70
M70
C40
BL70

B | Y30
M40
C50
BL40

C | Y30
M50
C40
BL40

D | Y20
M20
C20
BL20

398

A | Y70
M40
C30
BL70

B | Y30
M40
C50
BL40

C | Y30
M30
C60
BL50

D | Y20
M20
C10
BL20

402

A | Y70
M70
C40
BL70

B | Y40
M50
C60
BL40

C | Y50
M40
C70
BL50

D | Y40
M40
C30
BL20

399

A | Y70
M50
C20
BL70

B | Y50
M30
C30
BL40

C | Y50
M30
C60
BL40

D | Y30
M20
C10
BL20

403

A | Y30
M70
C60
BL70

B | Y60
M50
C50
BL40

C | Y20
M60
C50
BL50

D | Y40
M20
C20
BL20

400

A | Y70
M50
C20
BL70

B | Y50
M40
C30
BL40

C | Y50
M50
C50
BL40

D | Y20
M20
C10
BL20

404

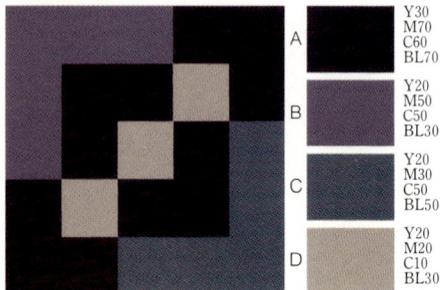

A | Y30
M70
C60
BL70

B | Y20
M50
C50
BL30

C | Y20
M30
C50
BL50

D | Y20
M20
C10
BL30

405

A	Y30 M60 C70 BL70
B	Y20 M50 C50 BL40
C	Y20 M30 C50 BL50
D	Y40 M30 C30 BL20

406

A	Y30 M60 C70 BL70
B	Y30 M50 C40 BL40
C	Y30 M50 C50 BL40
D	Y20 M30 C10 BL20

407

A	Y40 M40 C70 BL70
B	Y50 M40 C30 BL30
C	Y30 M50 C50 BL40
D	Y40 M30 C30 BL20

408

A	Y40 M40 C70 BL70
B	Y40 M50 C30 BL30
C	Y50 M30 C50 BL40
D	Y40 M30 C20 BL20

409

A	Y50 M30 C70 BL70
B	Y50 M30 C30 BL30
C	Y50 M30 C60 BL40
D	Y30 M20 C10 BL20

410

A	Y50 M30 C70 BL70
B	Y40 M50 C40 BL30
C	Y30 M40 C50 BL40
D	Y30 M20 C20 BL20

411

A	Y70 M40 C70 BL70
B	Y50 M60 C30 BL40
C	Y50 M50 C40 BL50
D	Y30 M30 C10 BL20

412

A	Y70 M40 C70 BL70
B	Y50 M30 C40 BL30
C	Y60 M50 C30 BL40
D	Y30 M20 C10 BL30

WARM/HOT

Similar images

- Robust
- Magnanimous

• The colors ranging from yellow to red, with orange as the main color, give a feeling of warmth and heat associated with the sun and fire. The quickest way to make a scheme with these colors is to compose the entire field using similar-color color schemes from the warm color group as well as gradations. Light and bright pastel tones make us think of the gentle warmth of spring. Among the pastels, pink is the most suitable color for expressing gentle warmth.

• When vivid tones are used, the impression goes from warm to hot. When deep tones are added, it becomes richer and even a bit stuffy.

• The terms *warm* and *hot* are the opposites of *cool* and *cold*. Warm and cool hues and hot and cold hues have opposing positions along the circle. Warm colors are expansive and appear to radiate energy, so areas thus colored appear larger. Cold colors are contractive, and their impression is of diminished energy moving inward.

Other references:
- Romantic (p. 8–9)
- Fruity & Juicy (p. 26–27)
- Pleasant (p. 66–67) • Spring (p. 97)
- Summer (p. 99)

413

A	Y80 M30
B	Y30 M70
C	Y80 M10
D	Y30 C50

414

A	Y80 M50
B	Y80 M70
C	Y80 M10
D	Y10 M80

415

A	Y80 M70
B	Y10 M70
C	Y80 M30
D	Y80 M50 C40

416

A	Y40 M80
B	Y80 M80
C	Y80 M30 C20
D	M80 C30

417

A	Y100 M10
B	Y100 M90
C	Y100 M30
D	Y100 M70

421

A	Y100 M10
B	Y100 M100
C	Y100 M60
D	Y100 M50 C30

418

A	Y100 M40
B	Y10 M100
C	M100 C20
D	Y100 M90

422

A	Y100 M40
B	Y100 M50 C30
C	Y100 M90
D	Y100 M80 C60

419

A	Y100 M80
B	M100 C30
C	Y90 M100
D	Y100 M50

423

A	Y100 M80
B	Y100 M100
C	M100 C30
D	Y100 M40 C20

420

A	Y100 M100
B	Y100 M70
C	M100 C20
D	Y100 C100

424

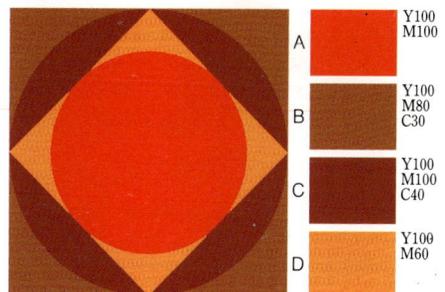

A	Y100 M100
B	Y100 M80 C30
C	Y100 M100 C40
D	Y100 M60

COOL/COLD

Similar images

- Cool
- Neat and Tidy
- Serene

• Blue hues are the major cold colors responsible for impressions of coolness and cold. Blues are associated with water, sky, shadow, and so forth. In addition, blues are associated with such elements as serenity, cleanness, and intellect.

• Because blue has a wide range, its impression differs somewhat depending on what kind of blue it is. When blue moves close to green, as in emerald and mint, it is more refreshing than cold. In addition to blue, lemon yellow is a color that shrouds us in coolness. When this somewhat metallic, sharp color is combined with blue, the color scheme becomes bright and refreshing. In order to communicate a heavy, chilly feeling, blue with gray is a good color scheme (see page 102, Winter).

• Coolness can be expressed not only by hue but also by variations in tone. Pale colors like the sherbet tones convey coolness even in warm colors like pink and orange. Night color schemes (p. 109), such as shown in examples 434, 435, and 436, look as if they are viewed through a blue filter, and their ambience is that of the underwater world.

Other references:
- Pale (p. 4–5) • Fantasia–like (p. 13)
- Refreshing (p. 14–15)
- Cool & Modern (p. 72–73)
- Summer (p. 98)
- Winter (p. 102)

425

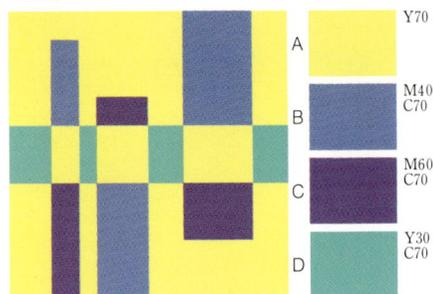

A — Y70
B — M40 C70
C — M60 C70
D — Y30 C70

426

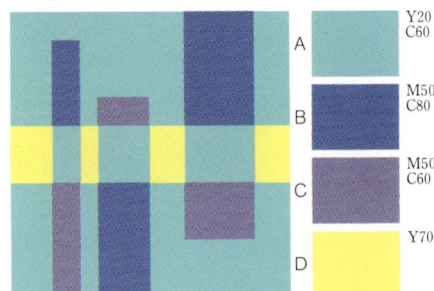

A — Y20 C60
B — M50 C80
C — M50 C60
D — Y70

427

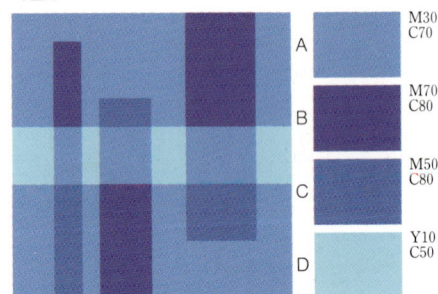

A — M30 C70
B — M70 C80
C — M50 C80
D — Y10 C50

428

A — M70 C80
B — Y10 C70
C — M60 C20
D — Y70 C10

429

A — Y90
B — M50 C80
C — M80 C100
D — Y80 C100

433

A — Y90
B — M60 C90
C — M70 C80
D — Y30 M50 C70

430

A — Y20 C90
B — M80 C100
C — M70 C60
D — Y40 C70

434

A — Y10 C90
B — M100 C90
C — Y100 M80 C80
D — M50 C100

431

A — M40 C80
B — M90 C100
C — Y100
D — Y10 C80

435

A — M60 C90
B — M100 C100
C — Y90 M100 C80
D — Y10 C80

432

A — M90 C100
B — M40 C80
C — M70 C60
D — M10 C70

436

A — Y40 C90
B — M100 C90
C — Y100 M80 C80
D — M90 C70

65

PLEASANT

Similar images

- Merry
- Robust
- Romantic
- Cute

• Memories of an amusement park linked to the world of fairy tales. The excitement felt upon entering a toy store or coming to the children's counter in a department store. Colorful candy boxes. Merry, pleasant, cheerful.

• It is more pleasant to have color than not to have it. It is more pleasant to have bright colors than to have dark ones. It is more pleasant to have warm colors than cold colors. Warm, clear, bright tones are precisely right for this pleasant feeling.

• Pink is essential because it is the symbol of happiness. It is the main color for the expression of pleasantness. With respect to the image associated with each color, orange is merry and robust. Purple is a bit fantastic. Even though mint and turquoise are blue, they are still fresh and sweet because they include some yellow.

• The most general way to compose this color scheme is to accent a similar-color color scheme with warm colors using mint and turquoise. Gradation techniques are also suitable for expressing a dreamy world.

Other references:

66

437

A	Y80 M20
B	Y80 M40
C	Y80 M70
D	Y40 M90

438

A	M70 C40
B	M70 C20
C	Y10 M70
D	Y50 M80

439

A	Y80 M50
B	Y30 M80
C	M80 C10
D	M80 C30

440

A	M90 C10
B	Y50 M90
C	Y80 M40
D	Y80

441

A Y80 M60
B M70 C50
C Y20 C70
D Y10 M80

445

A M70 C60
B Y80 M30
C M90
D Y80 M80

442

A Y20 C80
B Y90 M30
C M90 C10
D Y60 M80

446

A Y20 M90
B Y90 M60
C Y90 M10
D M90 C10

443

A Y50 M60
B M80 C30
C M60 C70
D Y20 M90

447

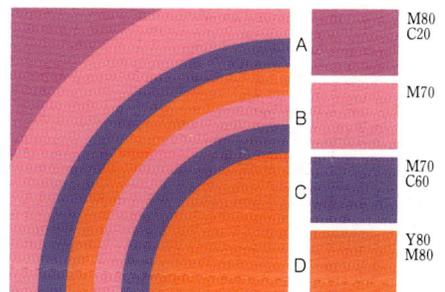

A M80 C20
B M70
C M70 C60
D Y80 M80

444

A Y40 C70
B M80 C50
C Y20 M90
D M70

448

A M70 C50
B Y80 M80
C M90
D Y20 C70

SOLITARY

Similar images

- Quiet
- Chic
- Simple

• In the world of colors, expressing the feeling of solitariness means using fewer colors. Vivid tones, those with rich coloring, bring us intense feelings free of any exertion. The abundance of color tones used in the festivals celebrated by many ethnic groups suggest the existence of a strong life force.

• In terms of hues, these color schemes are based on cold colors, such as blue and purple, which calm us. The tones are grayish. Like subdued colors, similar-color and cognate-color color schemes make us feel that the richness of the colors has waned. The same can be said about differences in lightness, but if those differences become too vague, they get washed out. Appropriate contrast will give shape to the schemes.

• When a clear color such as black or one with high saturation color is added even to a small area, the image becomes modern. So, if only grayish colors are used, it is lovely even if solitary. Also, night color schemes (see page 112) such as those shown in examples 449, 456, and 459, are effective even if a bit dreamy. In general, this is a composed and quiet color scheme.

Other references:
• Subdued (p. 56–61) • Winter (p. 103)

449

A	Y70 M40 C30 BL50
B	Y40 M40 C40 BL20
C	Y30 M30 C20 BL20
D	Y10 M10 C30 BL20

450

A	Y70 M40 C30 BL50
B	Y20 M30 C50 BL40
C	Y30 M30 C30 BL20
D	Y30 M20 C10 BL20

451

A	Y70 M50 C20 BL50
B	Y50 M30 C40 BL40
C	Y40 M30 C30 BL30
D	Y10 M20 C20 BL20

452

A	Y70 M50 C20 BL50
B	Y30 M40 C50 BL40
C	Y20 M50 C50 BL20
D	Y20 M20 C10 BL20

453

A	Y30 M70 C70 BL50
B	Y40 M40 C50 BL40
C	Y40 M40 C30 BL30
D	Y30 M20 C20 BL20

457

A	Y30 M30 C70 BL50
B	Y20 M30 C50 BL40
C	Y50 M30 C30 BL30
D	Y20 M20 C20 BL10

454

A	Y30 M70 C70 BL50
B	Y30 M40 C50 BL40
C	Y20 M50 C40 BL30
D	Y20 M20 C20 BL20

458

A	Y30 M30 C70 BL50
B	Y20 M40 C50 BL40
C	Y20 M30 C50 BL30
D	Y10 M10 C30 BL30

455

A	Y30 M50 C70 BL50
B	Y20 M30 C50 BL40
C	Y40 M40 C30 BL30
D	Y20 M20 C10 BL20

459

A	Y60 M30 C70 BL50
B	Y40 M50 C30 BL40
C	Y40 M30 C30 BL30
D	Y20 M10 C30 BL20

456

A	Y30 M50 C70 BL50
B	Y30 M40 C50 BL40
C	Y10 M30 C30
D	Y10 M10 C30 BL20

460

A	Y60 M30 C70 BL50
B	Y40 M30 C50 BL40
C	Y50 M30 C20 BL30
D	Y30 M20 C10 BL20

DRY

Similar images

- **Natural**

• In hues, these are warm colors from yellow to red. In tone, they are mostly dull. So, instead of yellow and red, they are khaki and red-brown. Since these colors are called natural colors or earthy colors, they are associated with dry soil and desert. When yellow, in particular, is added, the color scheme calls to mind a blazing sun.

• This color scheme is basically well-organized because of the similar-color color schemes that use warm colors. The most general way to make up this scheme is to connect yellows and reds using beige with sepia and olive for accents. Similar color schemes and related color schemes settle better when lightness values are clearly differentiated.

• Powdery tones, as if white paint were mixed in, exactly suit the expression of dryness. The colors for which 100% is used in printing, such as vivid, deep, and dark tones, have a glossy, transparent feeling and express wetness well, so they can be used as a point. Papers like high-quality paper and Japanese paper or cloth such as linen and cotton impart just the right feeling, because they have a little roughness about them. This color scheme has the flavor of folk art.

Other references:
• Natural (p. 25)

461

A	Y30 M10 C10
B	Y40 M30 C20
C	Y50 M40 C30
D	Y50 M50 C30

462

A	Y40 M20 C20
B	Y50 M40 C10
C	Y50 M40 C50
D	Y60 M50 C50

463

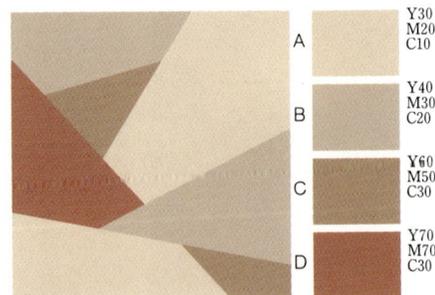

A	Y30 M20 C10
B	Y40 M30 C20
C	Y60 M50 C30
D	Y70 M70 C30

464

A	Y30 M20 C10
B	Y40 M30 C30
C	Y70 M40 C20
D	Y50 M70 C40

465

A	Y50 M20 C10
B	Y50 M30 C20
C	Y70 M50 C30
D	Y80 M80 C30

469

A	Y70 M20 C10
B	Y70 M40 C10
C	Y80 M50 C20
D	Y80 M70 C70

466

A	Y50 M20 C10
B	Y60 M40 C30
C	Y70 M70 C30
D	Y60 M80 C50

470

A	Y70 M20 C10
B	Y70 M50 C10
C	Y60 M50 C50
D	Y70 M60 C70

467

A	Y50 M20 C20
B	Y70 M50 C20
C	Y80 M80 C20
D	Y60 M70 C60

471

A	Y70 M30 C10
B	Y70 M50 C30
C	Y70 M80 C10
D	Y80 M70 C40

468

A	Y40 M30 C20
B	Y70 M50 C30
C	Y80 M70 C20
D	Y70 M80 C50

472

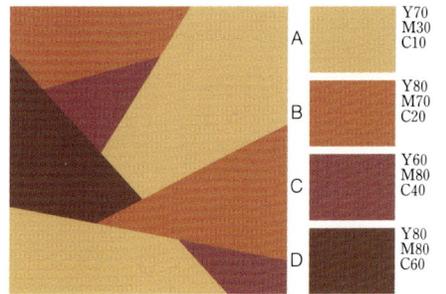

A	Y70 M30 C10
B	Y80 M70 C20
C	Y60 M80 C40
D	Y80 M80 C60

COOL & MODERN

Similar images

- Sharp
- Cold
- Inorganic

• To create this scheme, simply use blues + grays. Then add black or white. Blue + gray hues express coolness. By making strong lightness contrasts, the entire scheme sharpens, and a feeling of modernness is thereby created. Add a little black or white, and you are done. Cold and solitary are similarly blues + grays, but cool and modern is set off from them by its lightness differences.

• Black and white monotone alone and black and white monotone with some vivid tones added are effective techniques for the expression of modern.

• Cold yellow + gray are also suitable for the expression of modern because the combination has a high-tech and sophisticated metropolitan feeling.

• Another important consideration is form. Geometric shapes like the rectangle and triangle and large bold patterns all contribute to modernizing the scheme. In the end, the expression of modern means to give a distinctive modulation to colors and shapes.

Other references:
• Elegant (p. 80–83) • Chic (p. 84)

473

A — Y20 C50
B — Y20 M50 C100
C — Y30 M30 C50
D — Y50 M40 C80

474

A — Y30 M10 C40
B — Y30 M80 C100
C — Y30 M30 C40
D — M40 C90

475

A — Y20 M20 C30
B — M70 C100
C — Y30 M30 C60
D — Y50 M20 C100

476

A — Y30 M20 C20
B — M80 C90
C — Y30 M40 C70
D — Y10 C100

477

A — Y20 M20 C50
B — M60 C100
C — Y40 M40 C50
D — Y50 M100 C70

481

A — Y20 M20 C30
B — Y20 C100
C — Y40 M40 C50
D — M90 C100

478

A — Y30 M40 C40
B — Y40 M20 C100
C — Y60 M50 C70
D — M100 C90

482

A — Y30 M20 C20
B — M50 C100
C — Y30 M40 C60
D — M100 C30

479

A — Y30 C50
B — M50 C100
C — Y40 M50 C80
D — M80 C100

483

A — Y20 M20 C20
B — M80 C100
C — Y30 M40 C60
D — Y100 C10

480

A — Y20 M10 C30
B — Y30 M70 C100
C — Y30 M30 C50
D — Y20 M20 C100

484

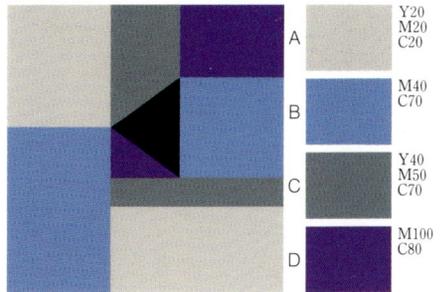

A — Y20 M20 C20
B — M40 C70
C — Y40 M50 C70
D — M100 C80

EXOTIC

Similar images

- Passionate
- Mysterious
- Southern
- Ethnic

• Exotic refers to an interest in things foreign. In the world of colors, however, this image overlaps the ethnic area—Oriental interests, tropical themes, and so on. This concept originated from a European point of view that sees Japanese tradition and culture as completely exotic.

• With respect to specific colors, we have such Oriental colors as turquoise and lapis lazuli, and tropical colors like vivid magenta, green, purple, and yellow-green. Color schemes using these colors produce an impression of the Oriental with a European sensibility. Such color schemes are filled with tropical associations.

• For color schemes, radical combinations of extreme colors with lots of opposing colors or similar-color color schemes using vivid colors are more stimulating and exotic. Night color schemes (p. 109) are also representative exotic color schemes. In any case, a bold use of a variety of colors is important.

Other references:
- Tropical (p. 30–31)
- Ethnic (p. 42–43)

485

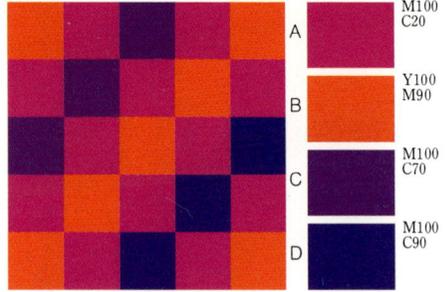

A	M100 C20
B	Y100 M90
C	M100 C70
D	M100 C90

486

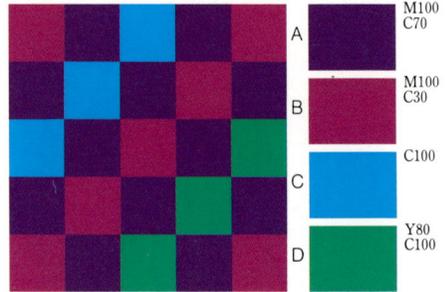

A	M100 C70
B	M100 C30
C	C100
D	Y80 C100

487

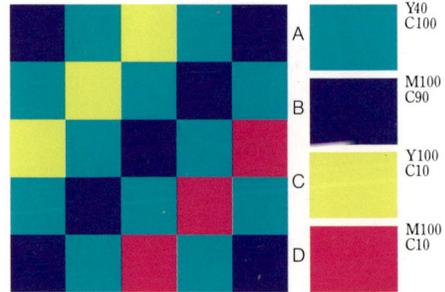

A	Y40 C100
B	M100 C90
C	Y100 C10
D	M100 C10

488

A	Y80 C100
B	M100
C	Y100 M90
D	M100 C70

489

A	Y20 M100
B	M90 C100
C	Y100 M70 C20
D	Y100 M30 C100

493

A	Y100 M50 C40
B	Y70 M100 C30
C	M100 C60
D	Y40 C100

490

A	M100 C20
B	Y100 M20
C	Y100 M60 C40
D	Y60 M40 C100

494

A	Y100 M80 C30
B	Y20 M90 C100
C	Y30 C100
D	M100 C50

491

A	M100 C100
B	Y50 C100
C	M100 C30
D	Y100 M70 C70

495

A	M100 C60
B	Y100 M60 C30
C	M100
D	Y60 C100

492

A	Y80 M40 C100
B	M100 C100
C	Y100 M70 C30
D	M100 C10

496

A	Y90 M100
B	M100 C90
C	Y100 M70 C20
D	Y100 M30 C100

497

A — Y100 M80 C80
B — M100
C — Y80 C100
D — M80 C80

501

A — Y90 M100 C70
B — Y30 C100
C — Y100 M60 C20
D — M100 C100

498

A — Y100 M80 C80
B — Y100 C100
C — Y90 M100
D — M90

502

A — Y90 M100 C70
B — Y100 C100
C — Y100 M80 C30
D — Y30 M100

499

A — Y100 M60 C90
B — Y100 M30
C — Y40 C100
D — M100 C40

503

A — Y100 M80 C90
B — Y20 C100
C — Y100 M80
D — M100 C40

500

A — Y100 M60 C90
B — M100 C30
C — Y20 M90
D — Y70 M90

504

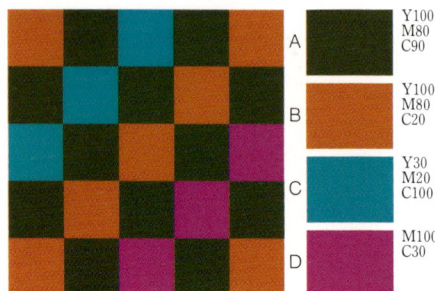

A — Y100 M80 C90
B — Y100 M80 C20
C — Y30 M20 C100
D — M100 C30

505

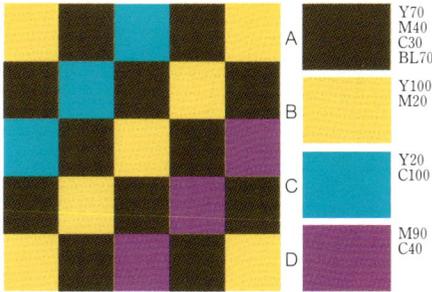

A	Y70 M40 C30 BL70
B	Y100 M20
C	Y20 C100
D	M90 C40

509

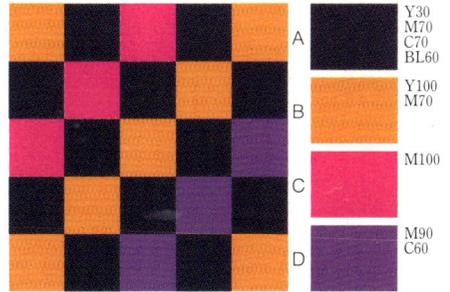

A	Y30 M70 C70 BL60
B	Y100 M70
C	M100
D	M90 C60

506

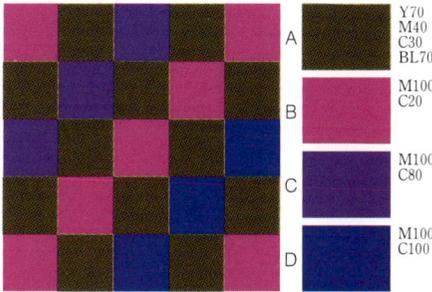

A	Y70 M40 C30 BL70
B	M100 C20
C	M100 C80
D	M100 C100

510

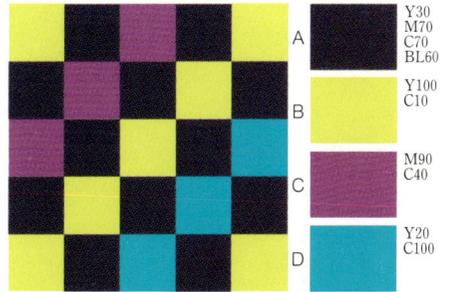

A	Y30 M70 C70 BL60
B	Y100 C10
C	M90 C40
D	Y20 C100

507

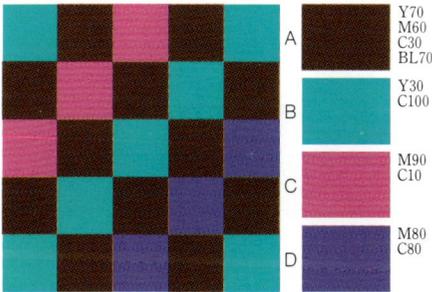

A	Y70 M60 C30 BL70
B	Y30 C100
C	M90 C10
D	M80 C80

511

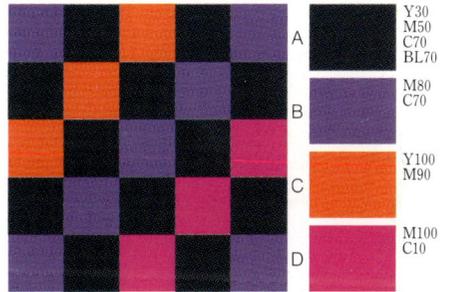

A	Y30 M50 C70 BL70
B	M80 C70
C	Y100 M90
D	M100 C10

508

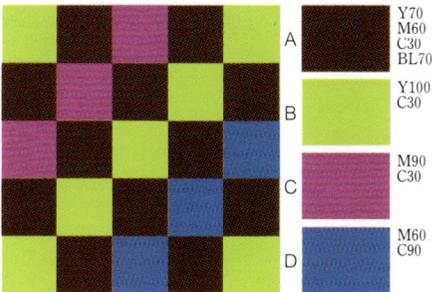

A	Y70 M60 C30 BL70
B	Y100 C30
C	M90 C30
D	M60 C90

512

A	Y30 M50 C70 BL70
B	Y40 C100
C	Y100 M80
D	M100 C30

513

A — Y100 M80
B — M100 C20
C — Y100 M40
D — Y100 M40 C20

517

A — Y100 C10
B — Y100 M40 C30
C — Y100 M60 C80
D — Y90 M100 C80

514

A — Y90 M100
B — Y10 M80
C — Y100 M50
D — Y100 M60 C20

518

A — Y10 C90
B — M60 C90
C — Y30 M40 C90
D — Y50 M90 C80

515

A — Y70 M100
B — Y60 M100 C40
C — M100 C20
D — Y100 M70 C20

519

A — M50 C90
B — Y30 C80
C — M90 C90
D — Y70 M90 C80

516

A — M100 C10
B — Y100 M60 C20
C — Y80 M80
D — Y10 M80

520

A — M80 C70
B — M80 C20
C — M50 C70
D — Y30 M70 C90

521

A Y100 M30
B M100 C20
C Y100 M60 C20
D Y80 M100 C80

525

A Y10 C90
B M80 C70
C Y90 M60 C70
D Y90 M80 C70

522

A Y20 M90
B Y90 M70 C60
C Y90 M50 C100
D Y90 M90 C80

526

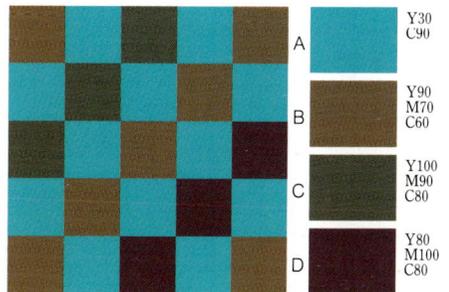

A Y30 C90
B Y90 M70 C60
C Y100 M90 C80
D Y80 M100 C80

523

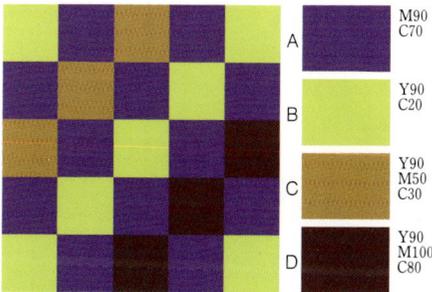

A M90 C70
B Y90 C20
C Y90 M50 C30
D Y90 M100 C80

527

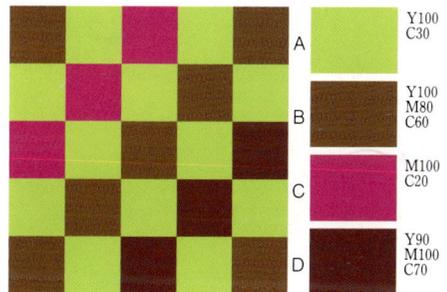

A Y100 C30
B Y100 M80 C60
C M100 C20
D Y90 M100 C70

524

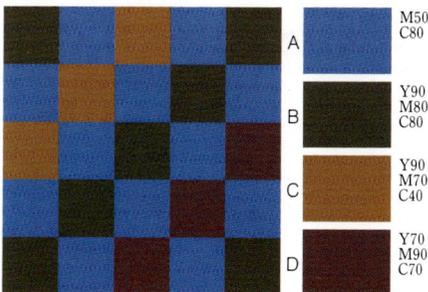

A M50 C80
B Y90 M80 C80
C Y90 M70 C40
D Y70 M90 C70

528

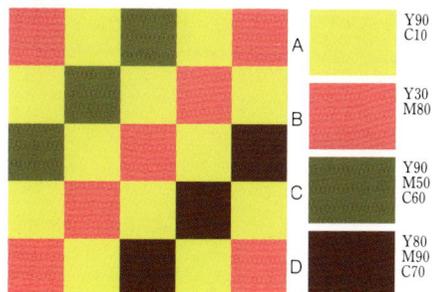

A Y90 C10
B Y30 M80
C Y90 M50 C60
D Y80 M90 C70

ELEGANT

Similar images

- Premium Quality
- Noble
- Stylish
- Lustrous

• Elegant means graceful. It is a refined and charming color scheme. Charming does not mean casual, but refers to a noble atmosphere. In Japanese style, it means tasteful.

• From pastel to deep, hue and tone choices are wide. Whatever choice you make, the key for the expression of elegance is combining colors with black and gray. The gaiety of vivid and deep colors becomes tasteful when black and gray are added. A graceful, refined dignity is engendered.

• When beige is used (as on page 82), the ambience is a bit different from that produced by using gray. It is softer and warmer.

• On page 83, there are examples using dark colors like sepia and navy blue. They are refined and composed elegant color schemes. Instead of those colors standing out as black does, they are allowed to become more closely allied with the other colors. Here, again, lightness contrasts are important and are one of the requirements for the expression of elegance.

Other references:
• Cool & Modern (p. 73)
• Chic (p. 84–85)

529

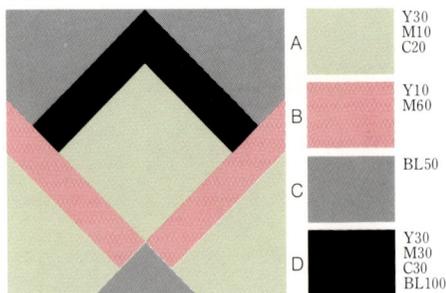

A — Y30 M10 C20
B — Y10 M60
C — BL50
D — Y30 M30 C30 BL100

530

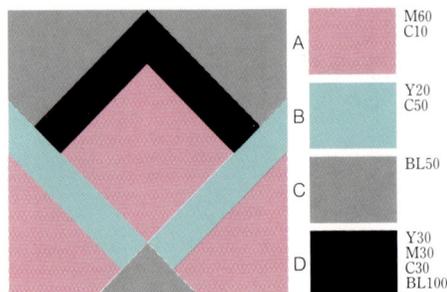

A — M60 C10
B — Y20 C50
C — BL50
D — Y30 M30 C30 BL100

531

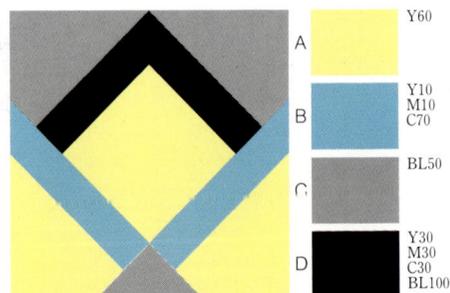

A — Y60
B — Y10 M10 C70
C — BL50
D — Y30 M30 C30 BL100

532

A — Y20 M70
B — M60 C70
C — BL50
D — Y30 M30 C30 BL100

533

A M100

B M100 C70

C BL50

D Y30 M30 C30 BL100

537

A Y30 M100 C40

B Y100 M50 C30

C BL50

D Y30 M30 C30 BL100

534

A Y20 C100

B M100 C90

C BL50

D Y30 M30 C30 BL100

538

A Y20 M100 C60

B Y100 M40 C20

C BL50

D Y30 M30 C30 BL100

535

A M100 C40

B Y70 C100

C BL50

D Y30 M30 C30 BL100

539

A Y20 M100 C80

B Y30 M20 C100

C BL50

D Y30 M30 C30 BL100

536

A Y100 M50

B M100 C100

C BL50

D Y30 M30 C30 BL100

540

A Y20 M100 C100

B Y60 M30 C100

C BL50

D Y30 M30 C30 BL100

541

A — Y60

B — Y30 C70

C — Y30 M30 C30

D — Y30 M30 C30 BL100

545

A — Y40 M30 C100

B — Y20 M100 C50

C — Y30 M30 C30

D — Y30 M30 C30 BL100

542

A — Y10 M40 C60

B — Y40 C70

C — Y30 M30 C30

D — Y30 M30 C30 BL100

546

A — Y20 M100 C20

B — Y100 M60 C70

C — Y30 M30 C30

D — Y30 M30 C30 BL100

543

A — Y10 M20 C60

B — M70 C30

C — Y30 M30 C30

D — Y30 M30 C30 BL100

547

A — Y50 M20 C100

B — Y20 M100 C80

C — Y30 M30 C30

D — Y30 M30 C30 BL100

544

A — Y20 M70

B — Y10 M70 C60

C — Y30 M30 C30

D — Y30 M30 C30 BL100

548

A — Y20 M90 C100

B — Y60 M20 C100

C — Y30 M30 C30

D — Y30 M30 C30 BL100

549

A	Y10 M40
B	Y70 M60 C50
C	Y40 M40 C20
D	Y90 M90 C80 BL20

553

A	Y20 M10 C10
B	Y40 M80 C60
C	Y20 M30 C50
D	Y40 M90 C80 BL30

550

A	Y20 M40 C40
B	Y40 M40 C70
C	Y20 M40
D	Y90 M80 C80 BL20

554

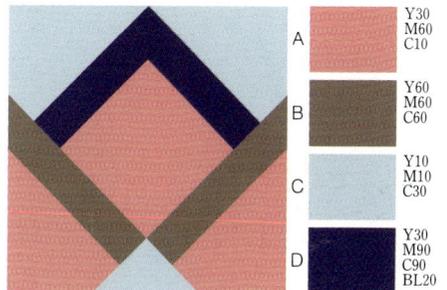

A	Y30 M60 C10
B	Y60 M60 C60
C	Y10 M10 C30
D	Y30 M90 C90 BL20

551

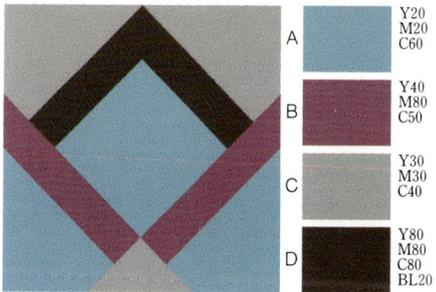

A	Y20 M20 C60
B	Y40 M80 C50
C	Y30 M30 C40
D	Y80 M80 C80 BL20

555

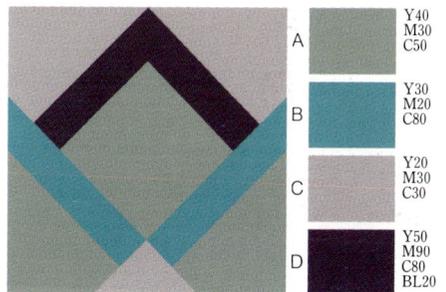

A	Y40 M30 C50
B	Y30 M20 C80
C	Y20 M30 C30
D	Y50 M90 C80 BL20

552

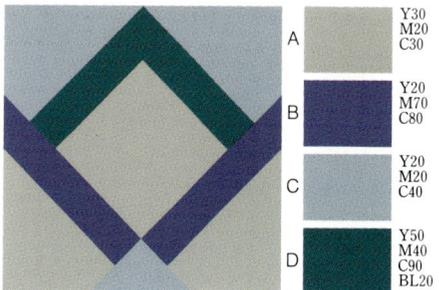

A	Y30 M20 C30
B	Y20 M70 C80
C	Y20 M20 C40
D	Y50 M40 C90 BL20

556

A	Y30 M10 C60
B	Y30 M60 C80
C	Y40 M20 C10
D	Y40 M60 C80 BL40

CHIC

Similar images

- Composed
- Stylish
- Sophisticated
- Art Deco

• Chic means refined and smart. Although elegant is also refined, it is more graceful, while chic is more stylish and intelligent. So, in arranging the colors, tranquil tones like dull and gray provide just the right ambience.

• Pages 84 and 85 offer examples that make use of black. When black is used, modern and classic coexist, and an Art Deco kind of modulation is brought forth. In terms of a Japanese sensibility, this scheme expresses stylishness. Black is a mysterious color that can emphasize the brilliance of any colors with which it is combined.

• Pages 86 and 87 contain examples that use dark colors other than black. Like black, these other dark colors create a scene that is well-coordinated with clear-cut contrasts.

• Generally speaking, besides dark colors, beiges and grays are the best choice for connecting colors. Because beiges and grays have neutral characteristics, they can be used without any problem as a third color. They are particularly important colors and are essential for composed, sophisticated, or refined chicness.

Other references:
- Subdued (p. 56–61)
- Solitary (p. 68–69)
- Cool & Modern (p. 72–73)
- Elegant (p. 83)

557

A — Y50 M30 C30
B — Y40 M40 C80
C — BL50
D — Y30 M30 C30 BL100

558

A — Y40 M50 C20
B — Y40 M70 C70
C — BL50
D — Y30 M30 C30 BL100

559

A — Y50 M40 C20
B — Y40 M60 C80
C — BL50
D — Y30 M30 C30 BL100

560

A — Y40 M30 C50
B — Y50 M70 C50
C — BL50
D — Y30 M30 C30 BL100

561

A — Y40 M30 C60
B — Y40 M20 C20
C — Y70 M60 C50
D — Y30 M30 C30 BL100

565

A — Y70 M60 C50
B — Y40 M60 C20
C — Y40 M50 C70
D — Y30 M30 C30 BL100

562

A — Y40 M30 C20
B — Y40 M60 C20
C — Y80 M70 C60
D — Y30 M30 C30 BL100

566

A — Y40 M30 C50
B — Y30 M20 C10
C — Y30 M40 C70
D — Y30 M30 C30 BL100

563

A — Y60 M50 C30
B — Y30 M20 C20
C — Y40 M60 C60
D — Y30 M30 C30 BL100

567

A — Y40 M50 C10
B — Y20 M10 C10
C — Y40 M60 C80
D — Y30 M30 C30 BL100

564

A — Y40 M60 C30
B — Y30 M20 C40
C — Y30 M60 C70
D — Y30 M30 C30 BL100

568

A — Y70 M50 C40
B — Y60 M50 C10
C — Y60 M50 C70
D — Y30 M30 C30 BL100

569

A
Y30
M20
C20
BL20

B
Y20
M20
C30

C
Y70
M50
C40

D
Y30
M50
C70
BL60

573

A
Y30
M50
C60

B
Y30
M20
C10

C
Y50
M30
C40
BL40

D
Y30
M100
C90
BL50

570

A
Y30
M50
C50
BL20

B
Y30
M20
C20

C
Y30
M40
C70
BL30

D
Y30
M50
C70
BL60

574

A
Y30
M30
C50

B
Y30
M20
C20

C
Y50
M40
C30
BL30

D
Y30
M100
C90
BL50

571

A
Y50
M30
C30
BL20

B
Y30
M20
C40

C
Y70
M60
C30

D
Y60
M40
C70
BL60

575

A
Y30
M20
C20
BL10

B
Y30
M30
C10

C
Y20
M50
C50
BL20

D
Y100
M90
C60
BL70

572

A
Y70
M40
C30

B
Y30
M20
C20
BL10

C
Y50
M40
C40
BL30

D
Y60
M40
C70
BL60

576

A
Y50
M40
C30

B
Y30
M20
C20
BL10

C
Y40
M40
C70

D
Y100
M90
C60
BL70

577

A	Y60 M60 C40
B	Y40 M30 C20
C	Y50 M30 C50 BL30
D	Y50 M70 C30 BL60

581

A	Y50 M40 C30 BL20
B	Y40 M30 C20
C	Y40 M40 C70
D	Y30 M60 C100 BL60

578

A	Y30 M20 C60
B	Y20 M20 C20 BL10
C	Y30 M50 C70 BL20
D	Y50 M70 C30 BL60

582

A	Y40 M40 C40 BL10
B	Y20 M10 C10
C	Y20 M60 C60 BL20
D	Y30 M60 C100 BL60

579

A	Y10 M10 C30 BL30
B	Y30 M20 C20
C	Y40 M30 C70
D	Y70 M50 C30 BL60

583

A	Y30 M30 C40 BL20
B	Y50 M40 C30
C	Y60 M60 C40 BL30
D	Y30 M80 C100 BL60

580

A	Y40 M50 C40 BL20
B	Y30 M20 C50
C	Y70 M60 C50
D	Y70 M50 C30 BL60

584

A	Y60 M60 C50
B	Y30 M20 C20 BL10
C	Y40 M70 C30 BL40
D	Y30 M80 C100 BL60

JAPANESE STYLE
*Folk Arts

Similar images

- Gentle - Refined

- Japanese style means Japanese sensibilities. In general, there is a strong impression of subdued and composed coloration. In practice, however, as in the costumes found in Kabuki and Noh, it is a gorgeous, resplendent, and color-rich world as well. Likewise, among traditional Japanese colors, there are many vivid and artificial dyes, but for the right impression, tones with controlled saturation create the proper ambience.

- Specifically, the color impressions of Japanese dress, Japanese sweets, Japanese paper, and Japanese toys are often used. In terms of the color scheme, there are three significant categories. One is an artistic color scheme, such as purple + a combination of yellow and blue. Another is a stylish and traditional urban color scheme. Finally, there is a folk art–type color scheme using browns and indigo.

- Specific examples of folk art color schemes are displayed on pages 94 and 95. Compared with other Japanese style color schemes, they are rich and close to ethnic color schemes. Night color schemes (p. 109) also convey a Japanese style image and are a valuable technique. In addition to Kyoto style and ukiyo-e, color fading is another image representative of Japanese style.

Other references:

585

A — Y70 M60 C20
B — Y50 M40 C40
C — Y70 M50 C80
D — Y90 M80 C70

586

A — Y30 M30 C30
B — Y30 M70 C50
C — Y50 M50 C20
D — Y40 M70 C80

587

A — Y50 M10 C40
B — Y50 M40 C60
C — Y70 M60 C30
D — Y80 M70 C70

588

A — Y50 M30 C20
B — Y40 M40 C40 BL10
C — Y50 M80 C50
D — Y80 M60 C50 BL40

589

A	Y50 M20 C20 BL30
B	Y40 M70 C50
C	Y30 M30 C30
D	Y70 M60 C80

590

A	Y30 M10 C40
B	Y70 M60 C20
C	Y30 M60 C60
D	Y50 M50 C40 BL60

591

A	Y50 M50 C50
B	Y70 M40 C70
C	Y30 M60 C70
D	Y90 M80 C70 BL20

592

A	Y20 M20 C30
B	Y40 M60 C60
C	Y30 M30 C40
D	Y70 M90 C70

593

A	Y30 M30 C30
B	Y50 M70 C40
C	Y30 M40 C60 BL10
D	Y30 M70 C50 BL60

594

A	Y30 M30 C40
B	Y30 M40 C50 BL30
C	Y20 M10 C30
D	Y30 M70 C30 BL50

595

A	Y30 M30 C50
B	Y80 M60 C40
C	Y20 M10 C20
D	Y70 M60 C30 BL60

596

A	Y50 M30 C20 BL30
B	Y90 M70 C50
C	Y30 M10 C20
D	Y70 M30 C70 BL50

597

A	Y30 M30 C40
B	Y40 M30 C80
C	Y30 M20 C20
D	Y70 M90 C70

601

A	Y30 M20 C60
B	Y80 M80 C50
C	Y60 M50 C50
D	Y50 M70 C30 BL60

598

A	Y30 M40 C50
B	Y70 M80 C50
C	Y40 M30 C30
D	Y30 M60 C70 BL50

602

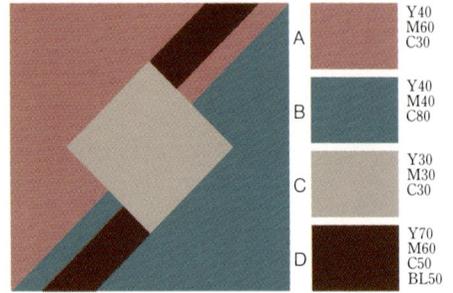

A	Y40 M60 C30
B	Y40 M40 C80
C	Y30 M30 C30
D	Y70 M60 C50 BL50

599

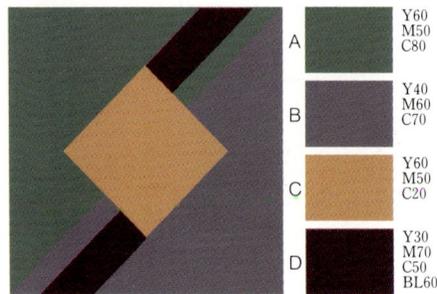

A	Y60 M50 C80
B	Y40 M60 C70
C	Y60 M50 C20
D	Y30 M70 C50 BL60

603

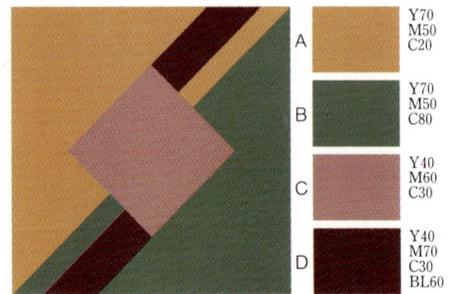

A	Y70 M50 C20
B	Y70 M50 C80
C	Y40 M60 C30
D	Y40 M70 C30 BL60

600

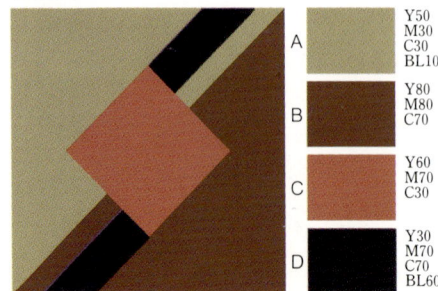

A	Y50 M30 C30 BL10
B	Y80 M80 C70
C	Y60 M70 C30
D	Y30 M70 C70 BL60

604

A	Y50 M30 C70
B	Y30 M70 C60
C	Y30 M70 C40
D	Y70 M60 C30 BL50

605

A	Y50 M40 C40 BL20
B	Y60 M40 C70
C	Y30 M60 C40
D	Y50 M30 C70 BL60

609

A	Y20 M40 C40
B	Y60 M40 C70
C	Y70 M70 C30 BL40
D	Y60 M80 C40

606

A	Y60 M30 C20
B	Y80 M60 C30
C	Y20 M40 C50
D	Y70 M70 C30 BL50

610

A	Y50 M30 C30
B	Y30 M50 C50
C	Y80 M80 C50 BL30
D	Y60 M50 C80

607

A	Y50 M30 C30
B	Y20 M80 C30
C	Y20 M10 C30
D	Y50 M70 C50 BL50

611

A	Y30 M20 C50
B	Y20 M60 C20
C	Y30 M70 C70 BL50
D	Y50 M60 C70

608

A	Y60 M50 C50
B	Y80 M80 C30
C	Y60 M20 C30
D	Y60 M80 C60 BL30

612

A	Y40 M30 C30 BL10
B	Y80 M70 C30
C	Y30 M60 C70 BL50
D	Y80 M50 C80

613

A	Y20 M30 C50
B	Y100 M100 C40
C	Y50 M30 C20
D	Y70 M50 C90

617

A	Y70 M30 C40
B	Y40 M100 C90
C	Y90 M70 C40
D	Y70 M50 C60

614

A	Y20 M20 C60
B	Y100 M80 C30 BL60
C	Y40 M70 C40
D	Y30 M70 C70

618

A	Y20 M40 C50
B	Y20 M100 C90 BL50
C	Y20 M10 C30
D	Y50 M80 C50

615

A	Y50 M50 C60
B	Y100 M100 C70 BL20
C	Y80 M30 C20
D	Y30 M20 C60

619

A	Y40 M30 C20
B	Y60 M60 C100
C	Y50 M20 C70
D	Y90 M90 C30

616

A	Y60 M10 C40
B	Y70 M100 C70
C	Y70 M50 C30
D	Y60 M50 C60

620

A	Y60 M50 C20
B	Y100 M50 C100 BL40
C	Y40 M40 C60
D	Y80 M90 C40

621

A	Y100 M90 C30
B	Y30 M70 C80
C	Y30 M40 C60
D	Y60 M30 C40

625

A	Y80 M60 C20
B	Y100 M70 C100
C	Y90 M80 C30
D	Y50 M100 C50 BL50

622

A	Y90 M100 C30
B	Y100 M40 C80 BL60
C	Y30 M50 C60
D	Y50 M30 C40

626

A	Y30 M80 C30
B	Y30 M100 C70
C	Y50 M20 C40
D	Y20 M30 C50 BL30

623

A	Y90 M80 C40
B	Y30 M100 C60 BL60
C	Y30 M20 C60
D	Y40 M40 C20

627

A	Y30 M70 C60
B	Y100 M30 C70 BL60
C	Y30 M70 C30
D	Y80 M50 C20

624

A	Y40 M20 C70
B	Y100 M90 C40
C	Y30 M50 C60
D	Y90 M90 C60 BL40

628

A	Y90 M30 C70
B	Y20 M100 C80
C	Y80 M40 C20
D	Y80 M60 C40

629

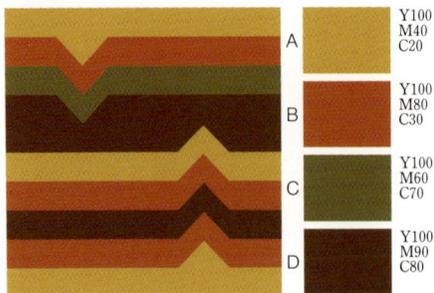

A Y100 M40 C20
B Y100 M80 C30
C Y100 M60 C70
D Y100 M90 C80

633

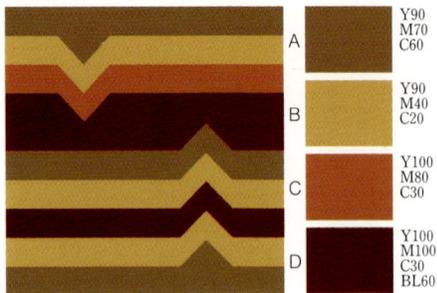

A Y90 M70 C60
B Y90 M40 C20
C Y100 M80 C30
D Y100 M100 C30 BL60

630

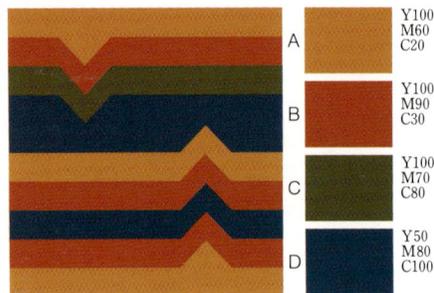

A Y100 M60 C20
B Y100 M90 C30
C Y100 M70 C80
D Y50 M80 C100

634

A Y100 M80 C70
B Y80 M100 C80
C Y100 M60 C20
D Y40 M60 C70

631

A Y100 M80 C30
B Y90 M40 C20
C Y100 M80 C60
D Y80 M30 C100 BL60

635

A Y80 M90 C30
B Y90 M60 C30
C Y100 M60 C70
D Y30 M90 C100 BL50

632

A Y100 M80 C30
B Y100 M70 C70
C Y90 M40 C30
D Y30 M70 C100 BL60

636

A Y90 M100 C30
B Y80 M40 C50
C Y60 M50 C80
D Y100 M80 C80

637

A	Y80 M100 C60
B	Y30 M20 C20 BL20
C	Y100 M70 C30
D	Y20 M100 C80 BL60

641

A	Y100 M80 C30 BL60
B	Y90 M90 C40
C	Y100 M50 C70
D	Y50 M80 C80

638

A	Y40 M80 C70
B	Y30 M30 C30
C	Y100 M80 C30 BL60
D	Y70 M30 C100 BL70

642

A	Y20 M100 C100 BL60
B	Y90 M70 C30
C	Y30 M60 C70
D	Y100 M80 C70

639

A	Y50 M90 C90
B	Y90 M100 C30
C	Y90 M50 C30
D	Y100 M90 C70 BL30

643

A	Y40 M50 C100 BL50
B	Y100 M90 C30
C	Y100 M70 C20
D	Y100 M90 C70 BL60

640

A	Y50 M50 C80
B	Y100 M90 C40
C	Y90 M60 C30
D	Y100 M30 C60 BL70

644

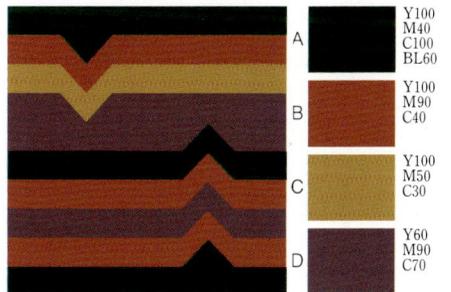

A	Y100 M40 C100 BL60
B	Y100 M90 C40
C	Y100 M50 C30
D	Y60 M90 C70

Spring • Summer
Autumn • Winter

• **Spring** The images of soft and gentle sunshine and of a merry and pleasant spring are pastel tones from light to bright. The degree of tonal depth is precisely keyed to the changes that occur during the springtime. From the very pale colors of early spring to the bright colors of midspring, these sunny colors are most important for their warmth and sweetness.

• **Summer** Because there is still a lingering impression of spring, the expression of early summer, when sunshine increases in intensity and radiance, is mainly attained through bright blues and greens, as shown on page 98. The examples on page 99 show the arrival of the real summer. The contrast between yellow and blue, which expresses heat by means of intensely opposed colors, expresses well-defined lights and shadows.

• **Autumn** This season is often conveyed by using specific natural colors such as reddening leaves, falling leaves, and fruit. From early autumn until late autumn, the natural colors, including yellow, become the core of this color scheme. Suggestive deep and dark tones have a mature ambience and are the representative tones of autumn.

• **Winter** There are a variety of winter images. One is of coldness and chilliness and is attained through the use of cold colors. For this, similar-color color schemes and cognate-color color schemes are effective. When suitable lightness differences are incorporated, the bracing chill of the air can be conveyed. When gray is added, the scheme grows colder.

• The representative tones for each season are as follows: spring = pastels, summer = vivid, autumn = deep, and winter = grayish.

645

A — Y30
B — M30
C — C40
D — Y30 C30

646

A — Y30
B — M40
C — Y30 M30
D — Y30 C30

647

A — Y30
B — Y10 C30
C — M30
D — M30 C30

648

A — Y10 C30
B — M40
C — Y30 M30
D — M30 C30

649

A — Y50
B — Y10 M50
C — Y20 C50
D — M20 C50

653

A — Y70
B — Y70 M20
C — Y70 C30
D — Y70 C70

650

A — Y50 M10
B — M50
C — Y30 C50
D — M50 C20

654

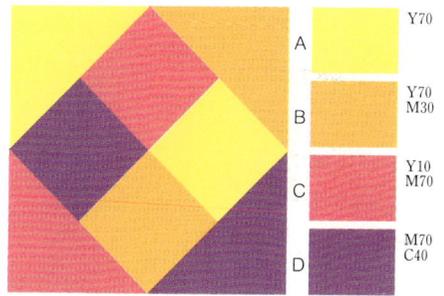

A — Y70
B — Y70 M30
C — Y10 M70
D — M70 C40

651

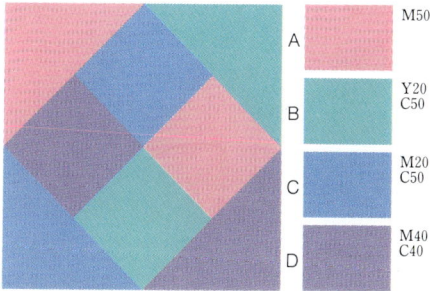

A — M50
B — Y20 C50
C — M20 C50
D — M40 C40

655

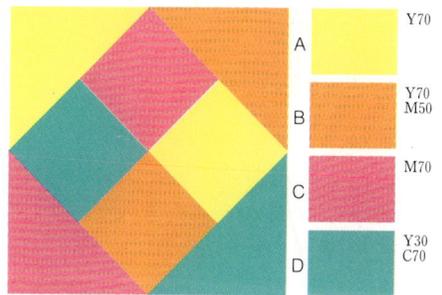

A — Y70
B — Y70 M50
C — M70
D — Y30 C70

652

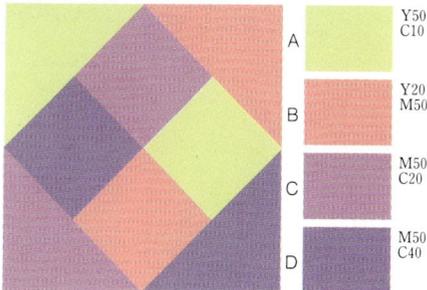

A — Y50 C10
B — Y20 M50
C — M50 C20
D — M50 C40

656

A — Y70
B — Y70 C30
C — Y30 M70
D — M70 C30

657

A — Y70 M10
B — Y30 C70
C — M30 C70
D — M60 C70

661

A — Y80 M10
B — Y80 M50
C — Y30 C70
D — M60 C70

658

A — Y70
B — Y70 C30
C — C70
D — M40 C70

662

A — Y80 M20
B — Y20 C80
C — M70 C50
D — M60 C80

659

A — Y70
B — Y80 M30
C — M50 C70
D — M70 C70

663

A — M20 C70
B — Y10 C70
C — M50 C70
D — M70 C80

660

A — Y80 C10
B — Y50 C70
C — M30 C70
D — M60 C70

664

A — Y80 C50
B — C70
C — M40 C70
D — M60 C80

665

A — Y100
B — Y20 C100
C — M30 C100
D — M70 C100

669

A — Y100 M20
B — Y100 M90
C — Y80 C100
D — M100 C80

666

A — Y100
B — Y100 M30
C — Y80 C100
D — M80 C100

670

A — Y100 M20
B — M100
C — M100 C30
D — Y70 C100

667

A — Y100 M10
B — Y100 M70
C — M30 C100
D — M90 C100

671

A — Y100 M50
B — Y90 M100
C — M100 C40
D — M80 C100

668

A — Y100 M10
B — Y90 M100
C — Y100 C100
D — M80 C100

672

A — Y100 M90
B — Y100 C100
C — M100 C50
D — M100 C70

99

673

A — Y50 M30 C20
B — Y50 M50 C20
C — Y30 M30 C70
D — Y30 M60 C70

677

A — Y70 M40 C10
B — Y70 M70 C30
C — Y60 M50 C70
D — Y40 M60 C80

674

A — Y50 M30 C20
B — Y60 M60 C20
C — Y70 M60 C40
D — Y70 M40 C80

678

A — Y60 M40 C20
B — Y80 M80 C10
C — Y80 M50 C60
D — Y80 M70 C70

675

A — Y60 M50 C10
B — Y60 M60 C30
C — Y70 M50 C50
D — Y60 M80 C50

679

A — Y70 M40 C30
B — Y60 M60 C50
C — Y50 M90 C50
D — Y80 M80 C70

676

A — Y60 M50 C20
B — Y60 M40 C50
C — Y60 M80 C40
D — Y30 M60 C80

680

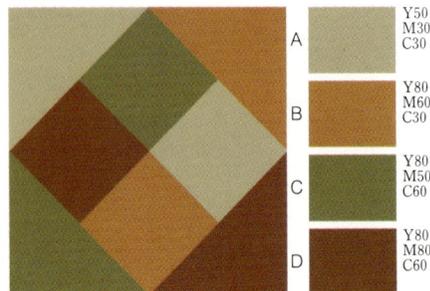

A — Y50 M30 C30
B — Y80 M60 C30
C — Y80 M50 C60
D — Y80 M80 C60

681

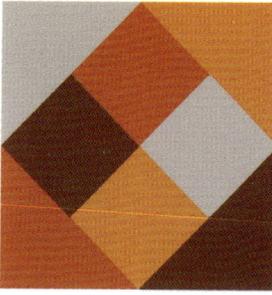

A	Y30 M30 C30
B	Y100 M60 C20
C	Y100 M80 C30
D	Y100 M80 C60 BL30

685

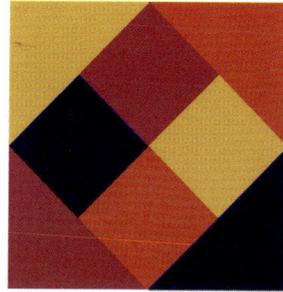

A	Y100 M40 C20
B	Y100 M90 C30
C	Y70 M100 C50
D	Y20 M100 C90 BL60

682

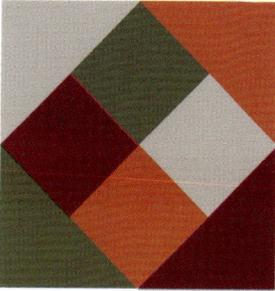

A	Y30 M30 C30
B	Y100 M90 C30
C	Y100 M70 C80
D	Y60 M100 C30 BL60

686

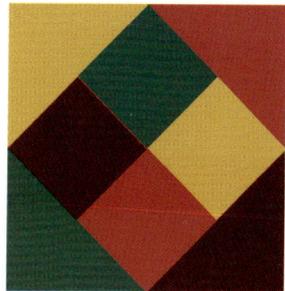

A	Y100 M40 C20
B	Y90 M100 C40
C	Y100 M70 C100
D	Y100 M90 C40 BL70

683

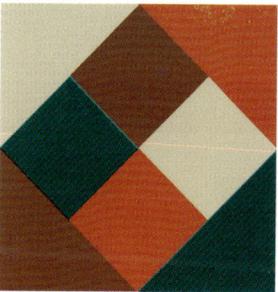

A	Y40 M20 C20
B	Y100 M90 C30
C	Y100 M90 C70
D	Y50 M30 C100 BL60

687

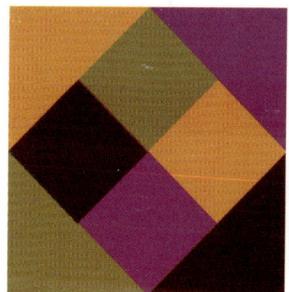

A	Y100 M60 C20
B	Y30 M100 C60
C	Y100 M60 C60
D	Y100 M100 C70 BL60

684

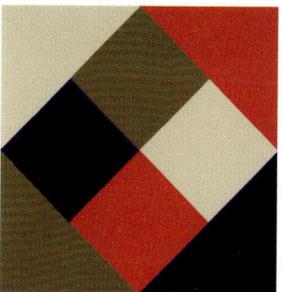

A	Y40 M20 C20
B	Y90 M100 C30
C	Y100 M70 C80
D	Y20 M100 C100 BL60

688

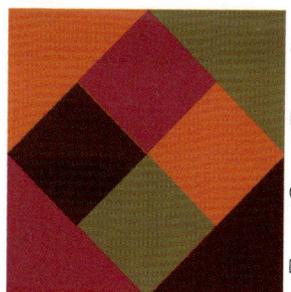

A	Y100 M80 C20
B	Y100 M60 C70
C	Y60 M100 C50
D	Y100 M80 C50 BL60

101

689

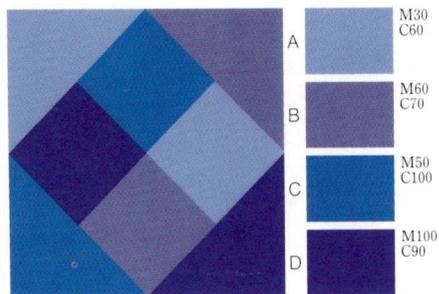

A — M30 C60
B — M60 C70
C — M50 C100
D — M100 C90

693

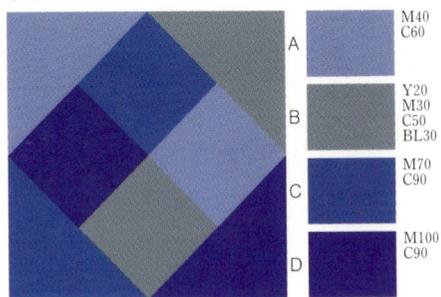

A — M40 C60
B — Y20 M30 C50 BL30
C — M70 C90
D — M100 C90

690

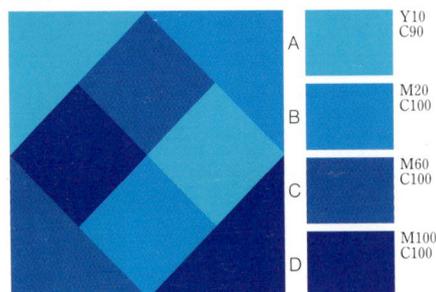

A — Y10 C90
B — M20 C100
C — M60 C100
D — M100 C100

694

A — M20 C60
B — Y20 M30 C50 BL30
C — M40 C90
D — M80 C100

691

A — Y20 C80
B — Y30 C100
C — Y10 M30 C100
D — Y40 M50 C100

695

A — Y10 C80
B — Y20 M20 C50 BL30
C — Y10 M20 C100
D — Y20 M70 C100

692

A — Y20 C60
B — Y20 C90
C — Y30 M20 C100
D — M90 C100

696

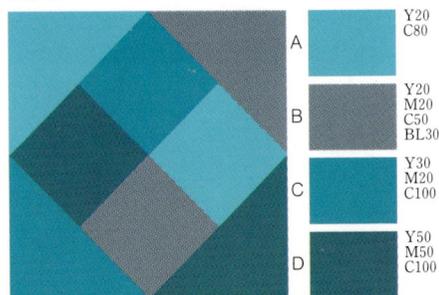

A — Y20 C80
B — Y20 M20 C50 BL30
C — Y30 M20 C100
D — Y50 M50 C100

697

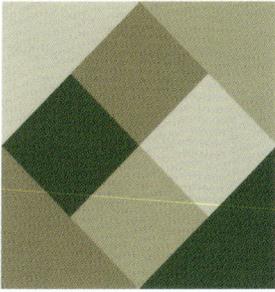

A	Y30 M10 C10 BL20
B	Y50 M20 C20 BL30
C	Y60 M30 C30 BL40
D	Y70 M30 C60 BL60

698

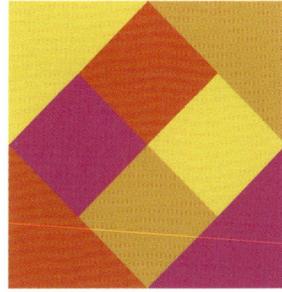

A	Y10 M20 C30 BL20
B	Y20 M40 C50 BL30
C	Y30 M50 C60 BL40
D	Y30 M60 C70 BL60

699

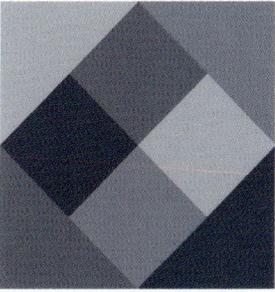

A	Y20 M10 C30 BL20
B	Y20 M20 C50 BL30
C	Y30 M30 C60 BL40
D	Y30 M40 C70 BL60

700

A	Y30 M10 C20 BL20
B	Y50 M20 C30 BL30
C	Y60 M40 C50 BL40
D	Y60 M40 C70 BL60

701

A	Y100 M20 C10
B	Y100 M50 C20
C	Y100 M90 C20
D	Y20 M100 C30

702

A	Y100 M30 C10
B	Y100 M90 C30
C	Y20 M100 C80
D	Y100 M30 C100 BL50

703

A	Y100 M30 C10
B	Y90 M100 C30
C	Y20 M100 C40
D	Y100 M80 C70 BL40

704

A	Y100 M60 C20
B	Y100 M90 C20
C	Y50 M100 C40
D	Y20 M100 C70 BL30

• Vivid • Deep + Dark • Dull

705

A Y100 C10
B Y100 M20
C Y100 M30

710

A Y100 M40 C20
B Y100 M60 C40
C Y100 M80 C50 BL30

715

A Y60 M30 C20
B Y70 M50 C20
C Y70 M40 C30

706

A Y100 M80
B Y100 M100
C M100 C10

711

A Y100 M60 C30
B Y100 M70 C60
C Y100 M90 C30 BL40

716

A Y70 M40 C30
B Y80 M60 C30
C Y80 M70 C60

707

A Y80 M100
B M100 C20
C M100 C40

712

A Y100 M90 C20
B Y100 M100 C40
C Y100 M100 C80

717

A Y70 M70 C20
B Y80 M70 C50
C Y60 M80 C30

708

A M100 C70
B M100 C100
C M50 C100

713

A Y20 M100 C80
B Y30 M100 C100
C Y30 M70 C100

718

A Y50 M70 C60
B Y40 M80 C80
C Y40 M70 C80

709

A M70 C100
B M40 C100
C Y30 C100

714

A Y20 M90 C100
B Y40 M50 C100
C Y50 M30 C100

719

A Y40 M40 C80
B Y40 M30 C70
C Y40 M20 C60

Gradation Color Schemes (see p. 111)
- Hue Variation (Light)　　　• Hue Variation (Bright)　　　• Lightness Variation

720

A — Y50 C10
B — Y50
C — Y50 M10

725

A — Y70
B — Y70 M10
C — Y70 M30

730

A — Y80
B — Y80 BL10
C — Y80 BL20

721

A — Y50 M40
B — Y50 M50
C — Y30 M50

726
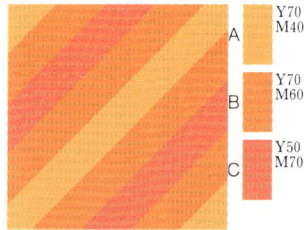

A — Y70 M40
B — Y70 M60
C — Y50 M70

731
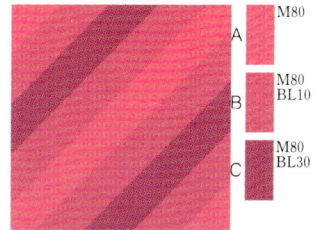

A — M80
B — M80 BL10
C — M80 BL30

722
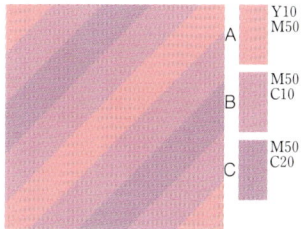

A — Y10 M50
B — M50 C10
C — M50 C20

727
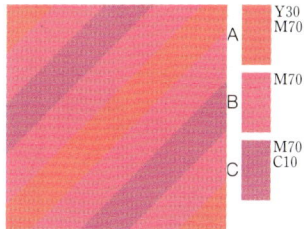

A — Y30 M70
B — M70
C — M70 C10

732

A — M80 C50
B — M80 C50 BL10
C — M80 C50 BL30

723

A — M40 C40
B — M30 C50
C — M10 C50

728

A — M70 C30
B — M70 C50
C — M70 C70

733

A — M30 C80
B — M30 C80 BL10
C — M30 C80 BL30

724

A — M10 C50
B — Y10 C50
C — Y20 C40

729

A — M30 C70
B — C70
C — Y20 C60

734

A — Y30 C80
B — Y30 C80 BL10
C — Y30 C80 BL30

735

A Y100 M10
B M100 C70
C M70 C100

740

A Y30 M10 C10
B Y40 M50 C100 BL50
C Y20 M100 C100 BL50

745

A Y10 M30 C10
B Y20 M80 C20
C Y30 M100 C40

736

A Y80 M100
B Y30 C100
C M50 C100

741

A Y30 M20 C20
B Y50 M50 C100 BL30
C Y50 M100 C50 BL60

746

A Y10 M20 C20
B Y20 M80 C80
C Y30 M100 C90

737

A M100 C70
B Y100 C70
C Y100 M30

742

A Y30 M30 C30
B Y100 M90 C30 BL50
C Y100 M40 C100 BL60

747

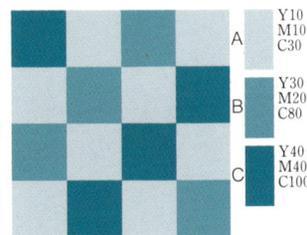

A Y10 M10 C30
B Y30 M20 C80
C Y40 M40 C100

738

A M70 C100
B Y100 M10
C Y100 M50

743

A Y20 M20 C30
B Y40 M100 C30 BL50
C Y30 M100 C70 BL60

748

A BL10
B BL70
C BL90

739

A Y40 C100
B Y10 M100
C Y100 M70

744

A Y30 M20 C30
B Y70 M50 C100 BL40
C Y30 M100 C90 BL60

749

A BL100
B BL10
C BL30

750

A Y20 M100

B M70 C100

755

A Y100 M80 C50 BL30

B Y50 M100 C30 BL50

C BL30

760

A Y100 M80 C40 BL30

B Y30 M100 C90 BL30

C Y30 M20 C20

751

A Y90 M100

B Y100 C100

756

A Y100 M100 C40 BL30

B Y30 M50 C100 BL50

C BL30

761

A Y100 M100 C40 BL30

B Y70 M60 C100 BL40

C Y30 M20 C20

752

A M100 C10

B Y90 M100

C Y30 M30 C30 BL100

757

A Y30 M100 C30

B Y30 M100 C60

C BL30

762

A Y50 M100 C70 BL30

B Y100 M90 C70 BL40

C Y30 M20 C20

753

A Y50 C100

B M60 C100

C Y30 M30 C30 BL100

758

A Y20 M100 C70

B Y20 M80 C100

C BL30

763

A Y50 M100 C30 BL30

B Y20 M100 C100 BL30

C Y30 M20 C20

754

A Y100 C100

B M100 C70

C Y30 M30 C30 BL100

759

A Y40 M30 C100

B Y20 M60 C100

C BL30

764

A Y30 M100 C60 BL30

B Y50 M50 C100 BL40

C Y30 M20 C20

107

• Hue Contrasts • Lightness Contrasts • Saturation Contrasts

765

A: Y100 M10
B: Y100 M40
C: M100 C90

770

A: Y100 M80 C30 BL60
B: Y60 M30 C100 BL70
C: Y20 M50 C10

775

A: Y50 M40 C30 BL50
B: Y40 M30 C20 BL30
C: Y20 C90

766

A: Y100 M90
B: M100 C10
C: Y80 C100

771

A: Y30 M100 C20 BL60
B: Y100 M80 C30 BL50
C: Y20 M10 C50

776

A: Y50 M50 C30 BL60
B: Y40 M40 C30 BL30
C: Y40 C90

767

A: M100 C80
B: M100 C50
C: Y100

772

A: Y20 M100 C80 BL60
B: Y20 M20 C100 BL50
C: Y50 M20 C10

777

A: Y30 M50 C60 BL50
B: Y40 M40 C40 BL30
C: Y90 M10

768

A: M70 C100
B: M100 C100
C: Y100 M20

773

A: Y20 M100 C100 BL60
B: Y100 M50 C20 BL60
C: Y10 M50 C10

778

A: Y30 M30 C50 BL60
B: Y30 M30 C50 BL30
C: Y10 M90

769

A: Y30 C100
B: M30 C100
C: Y100 M80

774

A: Y60 M30 C100 BL60
B: Y20 M80 C100 BL60
C: Y20 M50 C10

779

A: Y50 M30 C50 BL60
B: Y40 M20 C30 BL30
C: Y40 M90

780

A M30 C50
B Y70 M70 C40
C Y80 M50 C60

785

A M50 C100
B Y100 M80 C30 BL60
C Y100 M40 C20 BL70

790

A Y30 M50 C70
B Y100 M90 C60
C Y100 M70 C70

781

A M10 C50
B Y80 M50 C50
C Y80 M60 C30

786

A M30 C100
B Y100 M60 C20 BL60
C Y80 M100 C30 BL50

791

A Y30 M40 C70
B Y100 M80 C70
C Y100 M90 C40

782

A C50
B Y70 M80 C40
C Y50 M80 C30

787

A M10 C100
B Y100 M100 C20 BL50
C Y100 M80 C40 BL70

792

A Y30 M30 C70
B Y100 M70 C50
C Y90 M90 C50

783

A Y10 C50
B Y40 M60 C50
C Y70 M80 C50

788

A Y30 C100
B Y100 M70 C40 BL60
C Y100 M90 C30 BL50

793

A Y40 M30 C70
B Y80 M90 C50
C Y100 M70 C60

784
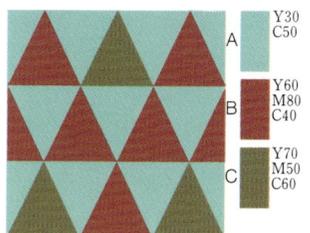

A Y30 C50
B Y60 M80 C40
C Y70 M50 C60

789
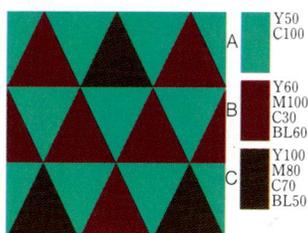

A Y50 C100
B Y60 M100 C30 BL60
C Y100 M80 C70 BL50

794
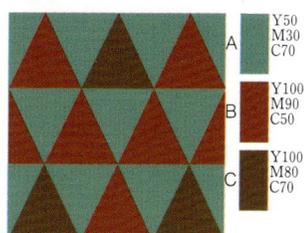

A Y50 M30 C70
B Y100 M90 C50
C Y100 M80 C70

Color Combination Techniques

We often hear the opinion that color schemes are difficult to create because it is not clear how to decide between good ones and bad. Color schemes are clearly difficult to deal with because they are in the arena of the senses, like music and taste, and in the world of the senses, there are no objective criteria.

On the other hand, it is possible to refine or nurture the senses. When you think about the reasons why color schemes are thought to be difficult, two in particular stand out.

One, naturally, is unfamiliarity. The uneasiness brought on by inexperience makes a person uncertain. Refining or nurturing the senses results from the extent to which the practitioner familiarizes himself or herself with colors and color schemes. Stockpiling this kind of experience allows a person to expand his or her sense of the arena of color scheme. In other words, gaining familiarity is more important than learning.

The other reason is indecisiveness. Indecisiveness in choosing between color A or color B is the same for the novice as it is for the expert. This is common in the world of the senses. Unfortunately, it is not just a matter of the goodness or badness of a color scheme. Difficulty and indecisiveness are basically different problems, but in many cases these two elements are confused, which only complicates color scheme technique. Nevertheless, by increasing one's experience, it is possible to focus in on the criteria for making a choice.

Another problem is loss of interest, which is caused by repetition and overuse of a color scheme. As is often experienced in the world of fashion, a color scheme that one really likes eventually grows boring when worn repeatedly. Without fail, new possibilities are desired. Nevertheless, during the period from indecisiveness to loss of interest, a sense for how to create and use a color scheme can definitely be obtained.

If we were to make a schematic of the structure of this sensory cycle, we would get the following:

Unfamiliarity (Inexperience) →Indecisiveness (Selection) →Freshness (Experience) →Familiarity (Repetition)→Loss of Interest (Dissatisfaction) →Groping (popularity) →Unfamiliarity.

In the end, a sense for color schemes is a cyclical progression. There are, however, some commonly applied techniques for combining colors. Of course, there is no equation that ensures a perfect solution for all occasions. So, it is acceptable to apply a way of thinking that is in accord with one's purpose. Practically speaking, 80% to 90% of color scheme technique involves combining. It is useful to know the characteristics of each technique and the differences in the feelings of the colors.

The Three Attributes of Color

Hue = Color group types, such as yellows, reds, blues, and greens.

Lightness = The degree of brightness or darkness of a color. In the hue circle, yellow is the brightest, and blue-purple is the darkest.

Saturation = The degree of vividness or dimness of a color. Pure colors are the most vivid.

Tone Color Scheme

The color domain that is expressed by such terms as *bright, vivid, dark, subdued*, and so on, is called tone. A tone color scheme means combining colors together that belong under the same general grouping. In other words, bright colors are combined into a bright color scheme, and subdued colors are combined into a subdued color scheme.

Because the color scheme derives from a group of related colors, the overall scheme appears as balanced. The key is to try to arrange the tones as perfectly as possible. This is fundamental to color schemes based on combining colors, and is especially effective in the case of a multicolor color scheme.

Similar-Color Color Scheme (p. 104)

A similar-color color scheme is a combination of colors whose hues are close to each other, for example, a yellow-orange color scheme, a blue-green color scheme, and so forth.

These color schemes are coherent because they include common colors that are drawn from among the three primaries. Since the hues are neighbors, the color scheme is quiet. But a hue characteristic such as warm or cold remains as it is. Color shades of a single hue create a cognate-color color scheme.

Gradation Color Scheme (p. 105)

A gradation color scheme is created when colors are arrayed in order according to their hue, lightness, or saturation. In short, it is a sequential color scheme.

It is characteristic of these color schemes that they stand out even when calm tones are used. Especially effective are hue gradations and lightness gradations. Consequently, this orderly rhythm is especially outstanding in our daily lives where many tones coexist in mutual abandon.

Rainbow colors are a kind of gradation. In a similar manner, gradation color schemes have a dreamlike effect on the viewer.

Contrast Color Scheme (p. 106)

A contrast color scheme is a combination of colors that are opposed in hue, lightness, or saturation. It is a clearly accentuated color scheme. In particular, lightness contrasts yield a distinct and clear-cut image, and a color scheme is sometimes acceptable just by differentiating between degrees of lightness. In terms of hue, vivid tones have the strongest contrast, and any opposite colors along the hue circle are compatible. In practice, contrasts in saturation are often employed as a one-point color scheme, such as title letters against a ground color. Such cases appear best organized when the ground is dark and the title letters are bright. Saturation contrasts are a bit more difficult than hue contrasts and lightness contrasts.

Separation Color Scheme (p. 107)

When two colors look unclear because their color values are similar or when the harshness of colors opposite in hue should be toned down, this technique is used.

When a neutral color is placed between two colors, neither of which it directly complements, it assumes the role of a connector for both

colors, and so the entire color scheme is well-arranged. This is called the separation effect.

As for the colors that are to serve as connectors, white and black are most effective and provide a clean appearance. Next is gray. Sometimes beige works well. This is a simple technique, but its effect is profound. Also, because the colors are not directly next to each other, color selection need not be a cause of indecisiveness. Color schemes for line drawings, such as those found in coloring books, are relatively easy to devise because of this effect. When white is inserted, the color scheme usually becomes neat and sporty.

In addition, gold and silver are heterogeneous materials, so they are effective as connecting colors.

One-Point Color Scheme (p. 108)

From the viewpoint of color scheme characteristics, the one-point color scheme is concerned with contrasts. Its effect derives from the division of the surface area into large and small regions with an opposing color set into the smaller area. The aim is to balance the whole scheme. For hue contrast and lightness contrast, either of the opposite colors can be used as the ground, but for saturation contrast, the schemes look better composed if a subdued color is used as the ground and a vivid color as the point.

Because this color scheme gives priority to shape, it is essential to calculate the shapes beforehand. This is also called accent coloring.

Day and Night Color Schemes (p. 109)

Day and night do not refer only to bright and dark color schemes. They also refer to light and shadow color schemes. In other words, they constitute the light and the shadow for color schemes.

In the world of hues, oranges, reds, and especially yellows act as substitutes for light. Assuming that yellow is the color of the daytime sun, orange and red are used for the evening sun or for the color of flames. In contrast, purples, greens, and especially blues represent shadow. Therefore, a color scheme with yellow and blue expresses most clearly the relationship between light and shadow. In general, a yellow-blue color scheme produces a strong midsummer impression with clearly defined shadows. Such a scheme is often used for beach parasols and soft-drink packaging.

Tutored by our experience, we sense that, whether natural light or artificial lighting is involved, light (yellow) is brighter than shadow (blue). In that case, if, shadow (blue) becomes light and light (yellow) becomes dark, this is the night color scheme.

Characteristic of night color schemes is the impression of things mysterious and exotic. Our senses, which are used to the world of ordinary light and shadow, are stimulated as if we were entering into an inverted world. In this world reversed, the mysterious impressions are like those we receive from photographic negatives or from the lighting of buildings at night. In nighttime lighting, any object that naturally creates shadow when lit from above receives its light from below. Because of this negative and positive reverse, an illusionary atmosphere is created.

Night color schemes where lightness values are reversed cannot be made within the same hue circle. Whether a hue circle is vivid or dark, yellows are always brighter than blues. In short, night color schemes can be created only from hue circles whose brightnesses are different, for instance, bright-toned blue and dark-toned yellow. Night color schemes convey a feeling of mystery because heterogeneous tones are combined.

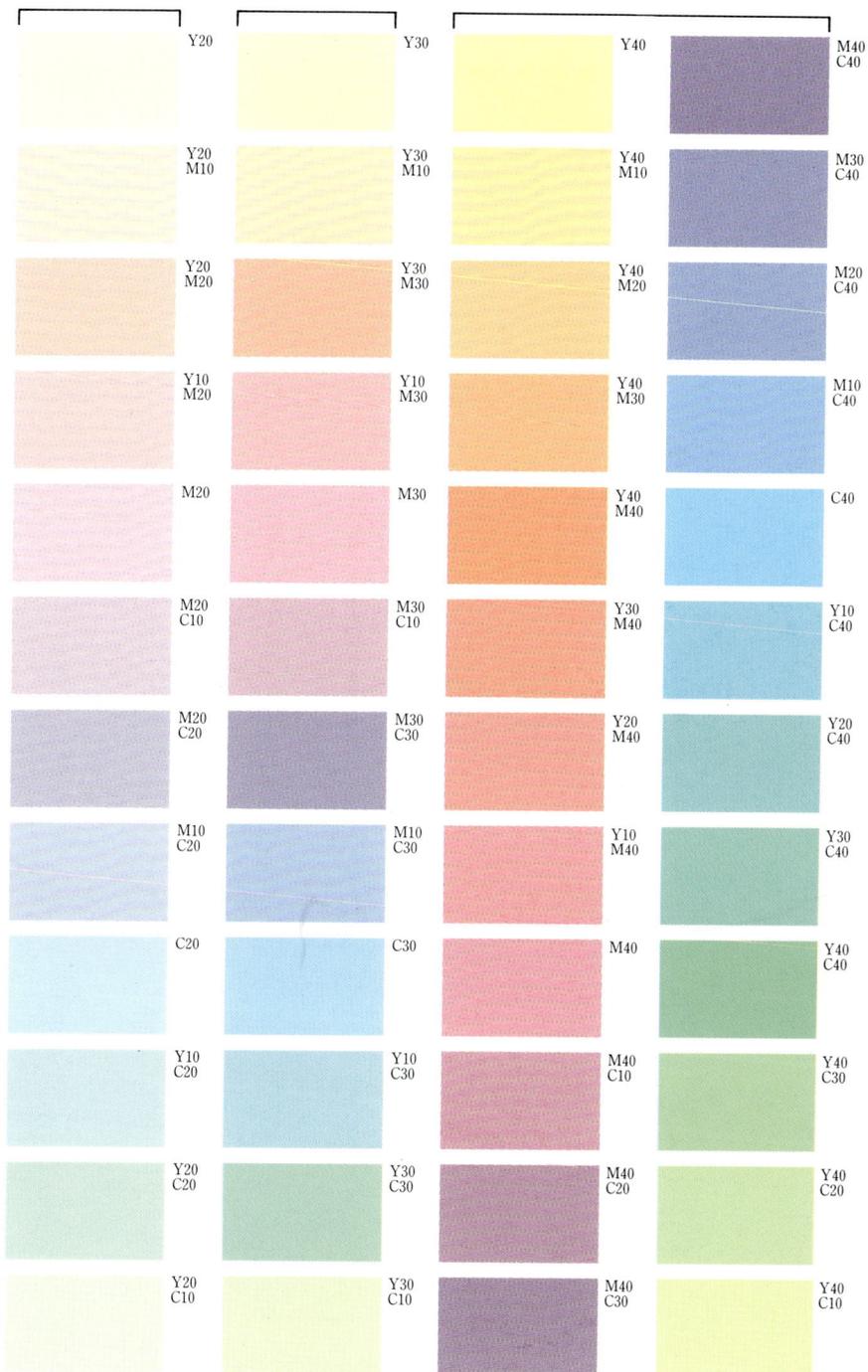

Appendix Color Chart [coated version]

Y20	Y30	Y40	M40 C40
Y20 M10	Y30 M10	Y40 M10	M30 C40
Y20 M20	Y30 M30	Y40 M20	M20 C40
Y10 M20	Y10 M30	Y40 M30	M10 C40
M20	M30	Y40 M40	C40
M20 C10	M30 C10	Y30 M40	Y10 C40
M20 C20	M30 C30	Y20 M40	Y20 C40
M10 C20	M10 C30	Y10 M40	Y30 C40
C20	C30	M40	Y40 C40
Y10 C20	Y10 C30	M40 C10	Y40 C30
Y20 C20	Y30 C30	M40 C20	Y40 C20
Y20 C10	Y30 C10	M40 C30	Y40 C10

113

bright

Y60	M60 C60	Y80	M80 C80
Y60 M10	M40 C60	Y80 M20	M60 C80
Y60 M20	M20 C60	Y80 M40	M40 C80
Y60 M40	M10 C60	Y80 M60	M20 C80
Y60 M60	C60	Y80 M80	C80
Y40 M60	Y10 C60	Y60 M80	Y20 C80
Y20 M60	Y20 C60	Y40 M80	Y40 C80
Y10 M60	Y40 C60	Y20 M80	Y60 C80
M60	Y60 C60	M80	Y80 C80
M60 C10	Y60 C40	M80 C20	Y80 C60
M60 C20	Y60 C20	M80 C40	Y80 C40
M60 C40	Y60 C10	M80 C60	Y80 C20

vivid

Y100	Y50 M100	M100 C100	Y50 C100
Y100 M10	Y40 M100	M90 C100	Y60 C100
Y100 M30	Y30 M100	M80 C100	Y80 C100
Y100 M40	Y10 M100	M60 C100	Y90 C100
Y100 M50	M100	M50 C100	Y100 C100
Y100 M60	M100 C10	M40 C100	Y100 C90
Y100 M80	M100 C30	M30 C100	Y100 C80
Y100 M90	M100 C40	M10 C100	Y100 C60
Y100 M100	M100 C50	C100	Y100 C50
Y90 M100	M100 C60	Y10 C100	Y100 C40
Y80 M100	M100 C80	Y30 C100	Y100 C30
Y60 M100	M100 C90	Y40 C100	Y100 C10

deep

Y100 M20 C20	Y20 M100 C100	Y100 M30 C30	Y30 M100 C100
Y100 M40 C20	Y20 M80 C100	Y100 M50 C30	Y30 M90 C100
Y100 M60 C20	Y20 M60 C100	Y100 M70 C30	Y30 M70 C100
Y100 M80 C20	Y20 M40 C100	Y100 M90 C30	Y30 M50 C100
Y100 M100 C20	Y20 M20 C100	Y100 M100 C30	Y30 M30 C100
Y80 M100 C20	Y40 M20 C100	Y90 M100 C30	Y50 M30 C100
Y60 M100 C20	Y60 M20 C100	Y70 M100 C30	Y70 M30 C100
Y40 M100 C20	Y80 M20 C100	Y50 M100 C30	Y90 M30 C100
Y20 M100 C20	Y100 M20 C100	Y30 M100 C30	Y100 M30 C100
Y20 M100 C40	Y100 M20 C80	Y30 M100 C50	Y100 M30 C90
Y20 M100 C60	Y100 M20 C60	Y30 M100 C70	Y100 M30 C70
Y20 M100 C80	Y100 M20 C40	Y30 M100 C90	Y100 M30 C50

dark

Y100 M20 C20 BL50	Y20 M100 C100 BL50	Y100 M30 C30 BL70	Y30 M100 C100 BL70
Y100 M40 C20 BL50	Y20 M80 C100 BL50	Y100 M50 C30 BL70	Y30 M90 C100 BL70
Y100 M60 C20 BL50	Y20 M60 C100 BL50	Y100 M70 C30 BL70	Y30 M70 C100 BL70
Y100 M80 C20 BL50	Y20 M40 C100 BL50	Y100 M90 C30 BL70	Y30 M50 C100 BL70
Y100 M100 C20 BL50	Y20 M20 C100 BL50	Y100 M100 C30 BL70	Y30 M30 C100 BL70
Y80 M100 C20 BL50	Y40 M20 C100 BL50	Y90 M100 C30 BL70	Y50 M30 C100 BL70
Y60 M100 C20 BL50	Y60 M20 C100 BL50	Y70 M100 C30 BL70	Y70 M30 C100 BL70
Y40 M100 C20 BL50	Y80 M20 C100 BL50	Y50 M100 C30 BL70	Y90 M30 C100 BL70
Y20 M100 C20 BL50	Y100 M20 C100 BL50	Y30 M100 C30 BL70	Y100 M30 C100 BL70
Y20 M100 C40 BL50	Y100 M20 C80 BL50	Y30 M100 C50 BL70	Y100 M30 C90 BL70
Y20 M100 C60 BL50	Y100 M20 C60 BL50	Y30 M100 C70 BL70	Y100 M30 C70 BL70
Y20 M100 C80 BL50	Y100 M20 C40 BL50	Y30 M100 C90 BL70	Y100 M30 C50 BL70

dull ①

Y30 M10 C10	Y60 M20 C20	Y80 M30 C30	Y30 M80 C80
Y30 M20 C10	Y60 M40 C20	Y80 M40 C30	Y30 M70 C80
Y30 M30 C10	Y60 M60 C20	Y80 M60 C30	Y30 M60 C80
Y20 M30 C10	Y40 M60 C20	Y80 M70 C30	Y30 M40 C80
Y10 M30 C10	Y20 M60 C20	Y80 M80 C30	Y30 M30 C80
Y10 M30 C20	Y20 M60 C40	Y70 M80 C30	Y40 M30 C80
Y10 M30 C30	Y20 M60 C60	Y60 M80 C30	Y60 M30 C80
Y10 M20 C30	Y20 M40 C60	Y40 M80 C30	Y70 M30 C80
Y10 M10 C30	Y20 M20 C60	Y30 M80 C30	Y80 M30 C80
Y20 M10 C30	Y40 M20 C60	Y30 M80 C40	Y80 M30 C70
Y30 M10 C30	Y60 M20 C60	Y30 M80 C60	Y80 M30 C60
Y30 M10 C20	Y60 M20 C40	Y30 M80 C70	Y80 M30 C40

dull ②

Y20 M10 C10	Y40 M20 C20	Y50 M30 C30	Y60 M40 C40
Y20 M20 C10	Y40 M30 C20	Y50 M40 C30	Y60 M50 C40
Y10 M20 C10	Y40 M40 C20	Y50 M50 C30	Y60 M60 C40
Y10 M20 C20	Y30 M40 C20	Y40 M50 C30	Y50 M60 C40
Y10 M10 C20	Y20 M40 C20	Y30 M50 C30	Y40 M60 C40
Y20 M10 C20	Y20 M40 C30	Y30 M50 C40	Y40 M60 C50
Y30 M20 C20	Y20 M40 C40	Y30 M50 C50	Y40 M60 C60
Y30 M30 C20	Y20 M30 C40	Y30 M40 C50	Y40 M50 C60
Y20 M30 C20	Y20 M20 C40	Y30 M30 C50	Y40 M40 C60
Y20 M30 C30	Y30 M20 C40	Y40 M30 C50	Y50 M40 C60
Y20 M20 C30	Y40 M20 C40	Y50 M30 C50	Y60 M40 C60
Y30 M20 C30	Y40 M20 C30	Y50 M30 C40	Y60 M40 C50

119

grayish

Y30 M10 C10 BL20	Y40 M20 C20 BL30	Y50 M30 C30 BL40	Y60 M40 C40 BL70
Y30 M20 C10 BL20	Y40 M30 C20 BL30	Y50 M40 C30 BL40	Y60 M50 C40 BL70
Y30 M30 C10 BL20	Y40 M40 C20 BL30	Y50 M50 C30 BL40	Y60 M60 C40 BL70
Y20 M30 C10 BL20	Y30 M40 C20 BL30	Y40 M50 C30 BL40	Y50 M60 C40 BL70
Y10 M30 C10 BL20	Y20 M40 C20 BL30	Y30 M50 C30 BL40	Y40 M60 C40 BL70
Y10 M30 C20 BL20	Y20 M40 C30 BL30	Y30 M50 C40 BL40	Y40 M60 C50 BL70
Y10 M30 C30 BL20	Y20 M40 C40 BL30	Y30 M50 C50 BL40	Y40 M60 C60 BL70
Y10 M20 C30 BL20	Y20 M30 C40 BL30	Y30 M40 C50 BL40	Y40 M50 C60 BL70
Y10 M10 C30 BL20	Y20 M20 C40 BL30	Y30 M30 C50 BL40	Y40 M40 C60 BL70
Y20 M10 C30 BL20	Y30 M20 C40 BL30	Y40 M30 C50 BL40	Y50 M40 C60 BL70
Y30 M10 C30 BL20	Y40 M20 C40 BL30	Y50 M30 C50 BL40	Y60 M40 C60 BL70
Y30 M10 C20 BL20	Y40 M20 C30 BL30	Y50 M30 C40 BL40	Y60 M40 C50 BL70

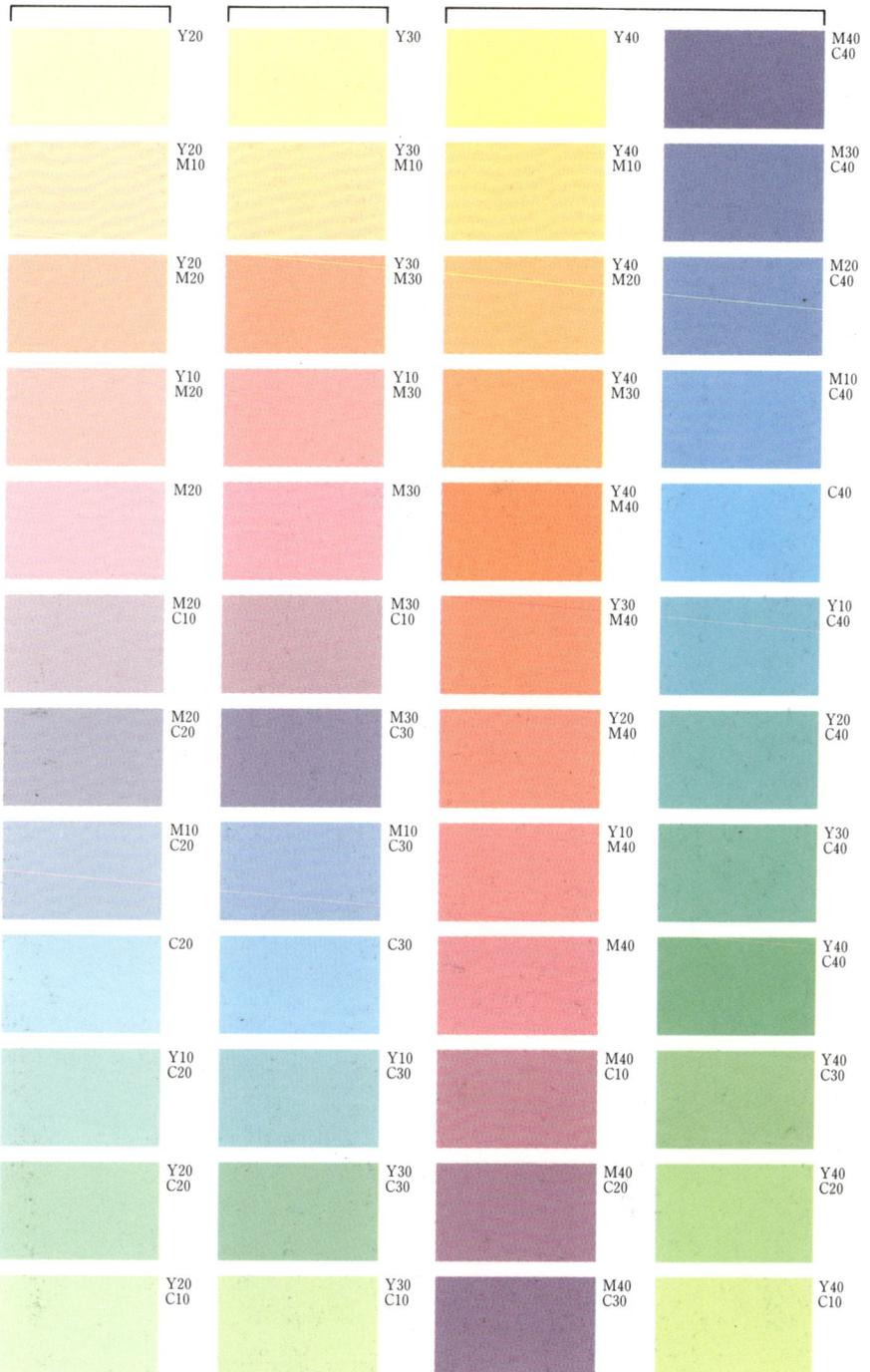

pale / light

Y20	Y30	Y40	M40 C40
Y20 M10	Y30 M10	Y40 M10	M30 C40
Y20 M20	Y30 M30	Y40 M20	M20 C40
Y10 M20	Y10 M30	Y40 M30	M10 C40
M20	M30	Y40 M40	C40
M20 C10	M30 C10	Y30 M40	Y10 C40
M20 C20	M30 C30	Y20 M40	Y20 C40
M10 C20	M10 C30	Y10 M40	Y30 C40
C20	C30	M40	Y40 C40
Y10 C20	Y10 C30	M40 C10	Y40 C30
Y20 C20	Y30 C30	M40 C20	Y40 C20
Y20 C10	Y30 C10	M40 C30	Y40 C10

bright

Y60	M60 C60	Y80	M80 C80
Y60 M10	M40 C60	Y80 M20	M60 C80
Y60 M20	M20 C60	Y80 M40	M40 C80
Y60 M40	M10 C60	Y80 M60	M20 C80
Y60 M60	C60	Y80 M80	C80
Y40 M60	Y10 C60	Y60 M80	Y20 C80
Y20 M60	Y20 C60	Y40 M80	Y40 C80
Y10 M60	Y40 C60	Y20 M80	Y60 C80
M60	Y60 C00	M80	Y80 C80
M60 C10	Y60 C40	M80 C20	Y80 C60
M60 C20	Y60 C20	M80 C40	Y80 C40
M60 C40	Y60 C10	M80 C60	Y80 C20

122

vivid

Y100	Y50 M100	M100 C100	Y50 C100
Y100 M10	Y40 M100	M90 C100	Y60 C100
Y100 M30	Y30 M100	M80 C100	Y80 C100
Y100 M40	Y10 M100	M60 C100	Y90 C100
Y100 M50	M100	M50 C100	Y100 C100
Y100 M60	M100 C10	M40 C100	Y100 C90
Y100 M80	M100 C30	M30 C100	Y100 C80
Y100 M90	M100 C40	M10 C100	Y100 C60
Y100 M100	M100 C50	C100	Y100 C50
Y90 M100	M100 C60	Y10 C100	Y100 C40
Y80 M100	M100 C80	Y30 C100	Y100 C30
Y60 M100	M100 C90	Y40 C100	Y100 C10

deep

Y100 M20 C20	Y20 M100 C100	Y100 M30 C30	Y30 M100 C100
Y100 M40 C20	Y20 M80 C100	Y100 M50 C30	Y30 M90 C100
Y100 M60 C20	Y20 M60 C100	Y100 M70 C30	Y30 M70 C100
Y100 M80 C20	Y20 M40 C100	Y100 M90 C30	Y30 M50 C100
Y100 M100 C20	Y20 M20 C100	Y100 M100 C30	Y30 M30 C100
Y80 M100 C20	Y40 M20 C100	Y90 M100 C30	Y50 M30 C100
Y60 M100 C20	Y60 M20 C100	Y70 M100 C30	Y70 M30 C100
Y40 M100 C20	Y80 M20 C100	Y50 M100 C30	Y90 M30 C100
Y20 M100 C20	Y100 M20 C100	Y30 M100 C30	Y100 M30 C100
Y20 M100 C40	Y100 M20 C80	Y30 M100 C50	Y100 M30 C90
Y20 M100 C60	Y100 M20 C60	Y30 M100 C70	Y100 M30 C70
Y20 M100 C80	Y100 M20 C40	Y30 M100 C90	Y100 M30 C50

dark

Y100 M20 C20 BL50	Y20 M100 C100 BL50	Y100 M30 C30 BL70	Y30 M100 C100 BL70
Y100 M40 C20 BL50	Y20 M80 C100 BL50	Y100 M50 C30 BL70	Y30 M90 C100 BL70
Y100 M60 C20 BL50	Y20 M60 C100 BL50	Y100 M70 C30 BL70	Y30 M70 C100 BL70
Y100 M80 C20 BL50	Y20 M40 C100 BL50	Y100 M90 C30 BL70	Y30 M50 C100 BL70
Y100 M100 C20 BL50	Y20 M20 C100 BL50	Y100 M100 C30 BL70	Y30 M30 C100 BL70
Y80 M100 C20 BL50	Y40 M20 C100 BL50	Y90 M100 C30 BL70	Y50 M30 C100 BL70
Y60 M100 C20 BL50	Y60 M20 C100 BL50	Y70 M100 C30 BL70	Y70 M30 C100 BL70
Y40 M100 C20 BL50	Y80 M20 C100 BL50	Y50 M100 C30 BL70	Y90 M30 C100 BL70
Y20 M100 C20 BL50	Y100 M20 C100 BL50	Y30 M100 C30 BL70	Y100 M30 C100 BL70
Y20 M100 C40 BL50	Y100 M20 C80 BL50	Y30 M100 C50 BL70	Y100 M30 C90 BL70
Y20 M100 C60 BL50	Y100 M20 C60 BL50	Y30 M100 C70 BL70	Y100 M30 C70 BL70
Y20 M100 C80 BL50	Y100 M20 C40 BL50	Y30 M100 C90 BL70	Y100 M30 C50 BL70

dull ①

Y30 M10 C10	Y60 M20 C20	Y80 M30 C30	Y30 M80 C80
Y30 M20 C10	Y60 M40 C20	Y80 M40 C30	Y30 M70 C80
Y30 M30 C10	Y60 M60 C20	Y80 M60 C30	Y30 M60 C80
Y20 M30 C10	Y40 M60 C20	Y80 M70 C30	Y30 M40 C80
Y10 M30 C10	Y20 M60 C20	Y80 M80 C30	Y30 M30 C80
Y10 M30 C20	Y20 M60 C40	Y70 M80 C30	Y40 M30 C80
Y10 M30 C30	Y20 M60 C60	Y60 M80 C30	Y60 M30 C80
Y10 M20 C30	Y20 M40 C60	Y40 M80 C30	Y70 M30 C80
Y10 M10 C30	Y20 M20 C60	Y30 M80 C30	Y80 M30 C80
Y20 M10 C30	Y40 M20 C60	Y30 M80 C40	Y80 M30 C70
Y30 M10 C30	Y60 M20 C60	Y30 M80 C60	Y80 M30 C60
Y30 M10 C20	Y60 M20 C40	Y30 M80 C70	Y80 M30 C40

dull ②

Y20 M10 C10	Y40 M20 C20	Y50 M30 C30	Y60 M40 C40
Y20 M20 C10	Y40 M30 C20	Y50 M40 C30	Y60 M50 C40
Y10 M20 C10	Y40 M40 C20	Y50 M50 C30	Y60 M60 C40
Y10 M20 C20	Y30 M40 C20	Y40 M50 C30	Y50 M60 C40
Y10 M10 C20	Y20 M40 C20	Y30 M50 C30	Y40 M60 C40
Y20 M10 C20	Y20 M40 C30	Y30 M50 C40	Y40 M60 C50
Y30 M20 C20	Y20 M40 C40	Y30 M50 C50	Y40 M60 C60
Y30 M30 C20	Y20 M30 C40	Y30 M40 C50	Y40 M50 C60
Y20 M30 C20	Y20 M20 C40	Y30 M30 C50	Y40 M40 C60
Y20 M30 C30	Y30 M20 C40	Y40 M30 C50	Y50 M40 C60
Y20 M20 C30	Y40 M20 C40	Y50 M30 C50	Y60 M40 C60
Y30 M20 C30	Y40 M20 C30	Y50 M30 C40	Y60 M40 C50

127

grayish

Y30 M10 C10 BL20	Y40 M20 C20 BL30	Y50 M30 C30 BL40	Y60 M40 C40 BL70
Y30 M20 C10 BL20	Y40 M30 C20 BL30	Y50 M40 C30 BL40	Y60 M50 C40 BL70
Y30 M30 C10 BL20	Y40 M40 C20 BL30	Y50 M50 C30 BL40	Y60 M60 C40 BL70
Y20 M30 C10 BL20	Y30 M40 C20 BL30	Y40 M50 C30 BL40	Y50 M60 C40 BL70
Y10 M30 C10 BL20	Y20 M40 C20 BL30	Y30 M50 C30 BL40	Y40 M60 C40 BL70
Y10 M30 C20 BL20	Y20 M40 C30 BL30	Y30 M50 C40 BL40	Y40 M60 C50 BL70
Y10 M30 C30 BL20	Y20 M40 C40 BL30	Y30 M50 C50 BL40	Y40 M60 C60 BL70
Y10 M20 C30 BL20	Y20 M30 C40 BL30	Y30 M40 C50 BL40	Y40 M50 C60 BL70
Y10 M10 C30 BL20	Y20 M20 C40 BL30	Y30 M30 C50 BL40	Y40 M40 C60 BL70
Y20 M10 C30 BL20	Y30 M20 C40 BL30	Y40 M30 C50 BL40	Y50 M40 C60 BL70
Y30 M10 C30 BL20	Y40 M20 C40 BL30	Y50 M30 C50 BL40	Y60 M40 C60 BL70
Y30 M10 C20 BL20	Y40 M20 C30 BL30	Y50 M30 C40 BL40	Y60 M40 C50 BL70

128